DRAW MORE FURRIES

HOW TO CREATE ANTHROPOMORPHIC FANTASY ANIMALS

Lindsay Cibos and Jared Hodges

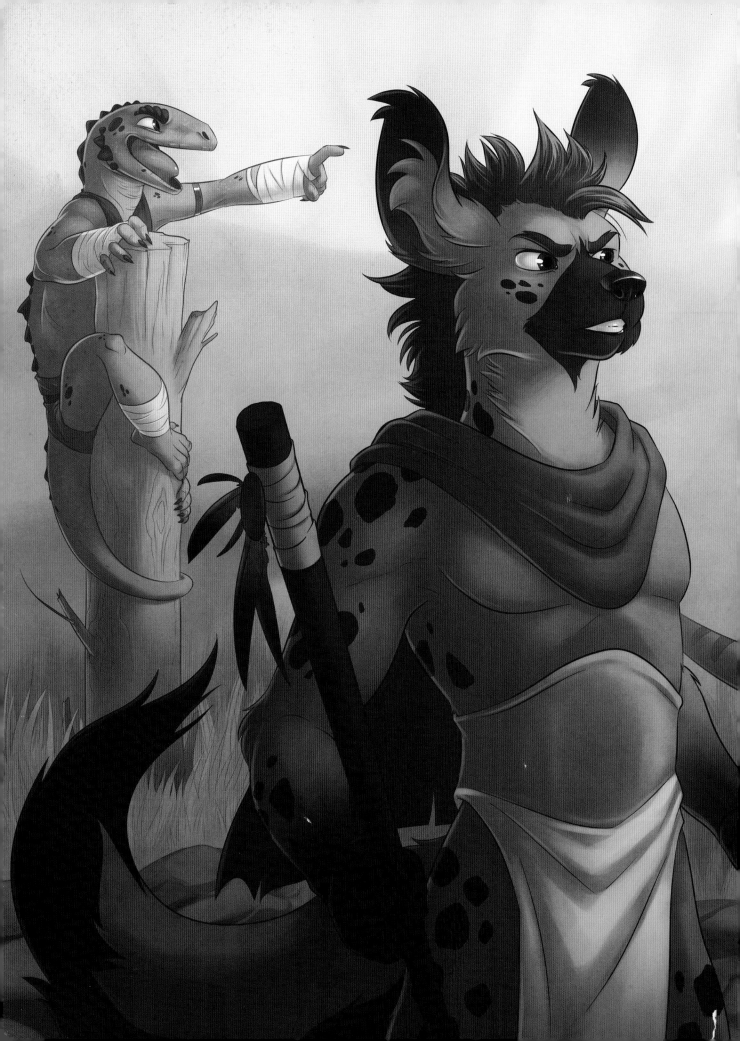

Draw More Furries

HOW TO CREATE ANTHROPOMORPHIC FANTASY ANIMALS

Lindsay Cibos and Jared Hodges

Heroes of the Tall Grass
by Kelly Hamilton

IMPACT
CINCINNATI, OHIO
www.impact-books.com

Contents

Introduction

In the labyrinth on the Isle of Crete, the Greek hero Theseus stands over the dying body of the Minotaur, a being with the head and tail of a bull but the body of a man. In the story, Theseus kills the only creature of its type in existence. But the Minotaur was not the first time people have imagined human-animal hybrids. In fact, these creatures are among us today—more numerous and varied than ever before. Ancient writers referred to these creatures, using a variety of terms: monsters, beasts and gods. In modern times, we can categorize all anthropomorphic animals (meaning animals with human characteristics) under the broad term of *furries*.

Adopted in the 1980s, the term *furry* has come to classify not just part-human, part-animal creatures, but an emergent culture of animal anthropomorphism enthusiasts. While the terminology is relatively new, evidence of furries in stories and art can be traced back to the dawn of recorded history. The ancient Egyptians, for example, had animalistic deities such as Anubis, a man with the head of a jackal. Anthropomorphic foxes, raccoon dogs and other animals were a recurring subject in classical Japanese ukiyo-e artwork. Further historical examples of furries can be found throughout the world, from Native American mythology to literary works.

Having survived the test of time, furries permeate pop culture. They commonly serve as mascots for sports teams and companies. And who isn't familiar with animation superstars like Mickey Mouse, Bugs Bunny and the Teenage Mutant Ninja Turtles? They're furries too.

Clearly, there's a fascination with anthropomorphic characters. Perhaps this is because animals can personify characteristics like strength and speed, or imbue a character with a fantastical visual element. There's also the appeal of animals in and of themselves.

Whatever the reason, furries exist all around us, and chances are, you have an interest in drawing them. We're here to help! Throughout the book, we'll walk you through the steps of creating a menagerie of anthropomorphic animals, from the fuzzy to the fantastical. So, grab your art supplies and let's draw furries!

Some Words to Know

Anthropomorphic: A nonhuman thing displaying human characteristics. For example, an anthropomorphic animal is an animal with human characteristics. The term comes from the Greek word, *anthropos* (meaning *human being*), and *morphe* (meaning *shape*).

Anthro: Shortened term for anthropomorphic animal.

Furries: Another term for anthropomorphic animals. Refers to any type of anthropomorphic animal, even those without fur. It can also be used to describe people who are fans of furry characters.

Scalies: Anthropomorphic reptiles and reptile-like creatures, including amphibians, dinosaurs and dragons.

Biped: Something that moves on two feet.

Quadruped: Something that moves on four legs.

Plantigrade: Walking on the sole of the foot.

Digitigrade: Walking on toes.

Unguligrade: Walking on hooves.

Furry Hybridization

To anthropomorphize means to attribute human characteristics to nonhuman things. An anthropomorphic animal, therefore, is the resulting hybrid of an animal mixed with human qualities. The degree of anthropomorphism is up to you, the artist, to decide. As you create your own anthropomorphic characters, ask yourself if you want more animal or human elements showing through in your characters.

Think of a scale, with a human on one side and an animal on the other. As you slide across a scale, the character becomes either more human or animal-like. Consider, for example, combining a human with a lynx. On one side of the scale, you have the lynx, the other side, a human. In between, there's every combination possible. You might choose to represent most of the lynx's features, like its muzzle, ears, tail, fur and paws, on a human body.

Or you could simply express the lynx's ears. Or, you could go the other way and depict a lynx with human expressiveness and intelligence. Both are valid approaches that blend the two basic elements of human and animal together to create distinct furry characters.

Lynx
The starting point for creating any furry character is the animal itself. Consider the qualities that make it unique and identifiable. For example, if you're anthropomorphizing a lynx, you might want to emphasize its stubby tail, spots, ear tufts and cheek ruffs. The extent of the features you include depends on how animal-like you want your character to look.

Human
The second half of the furry equation: the human element. Although the hair framing her face might remind us of the lynx's signature cheek ruffs, she's just your average human female.

Human With Animal Features

Here's an example of an anthro that's closer to the human side of the hybrid scale. While she has some lynx features, such as the ears, fangs and a pink-tipped nose, her face remains mostly human.

Anthropomorphic Lynx

Somewhere in the middle of the human and lynx scale, you get this resulting anthro. The human aspects include her body proportions, upright posture, clothes, head of hair and expressiveness. Her lynx features include the ears, muzzle, fur pattern, tail, paws and digitigrade stance.

Art Style

Style is your individual approach to art. This includes the elements you choose to express or emphasize in your work, such as your drawing and coloring techniques, the level of detail and even character proportions.

If you're just starting out, you may not have your own defined style yet. That's okay! Your style will develop naturally. As you practice drawing anthro characters, you'll discover the approach that works best for you.

Let's look at some common stylistic approaches to drawing anthro characters. Although each example uses a rabbit as the subject matter, notice how the results vary widely based on the approach.

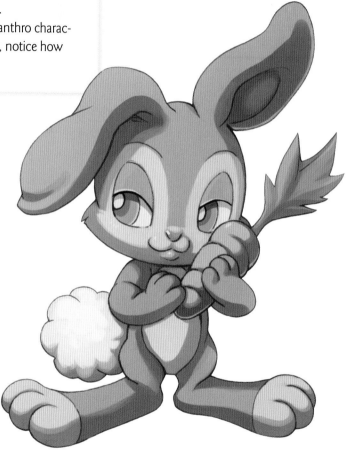

Cute and Round
This little guy is drawn soft and round, with minimal details. His large head and big eyes give him baby-like proportions for instant "awww" appeal. He gets an extra boost of bunny cuteness from his enlarged rabbit features (feet, ears and tail).

Get to Know Your Subject Matter
Regardless of whether your art style is cartoony or realistic, it's always a good idea to start by looking at photos and videos of the animal you're anthropomorphizing. Practice sketching the animal to familiarize yourself with its physical traits. From there, how closely you stick to the animal's appearance depends on you. The more realistic your art style, the more careful you'll need to be about accuracy in the details.

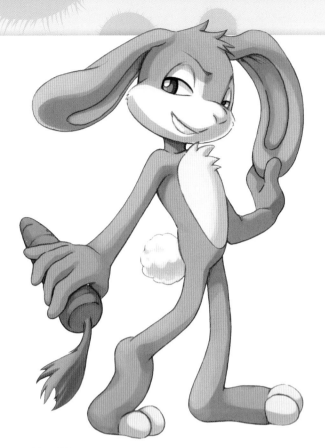

Toon Mascot

The low detail lines, simple coloring and child-like proportions make this rabbit ideal for a cartoon mascot character. His elongated body and limbs give him more pose flexibility than the Cute and Round rabbit.

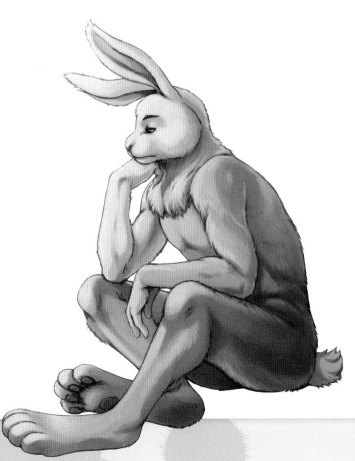

Semirealistic

Here's an anthro with the proportions of a teenage human boy. The hair on top of his head is longer and styled like human hair. He dresses the part as well.

While he still has big bunny feet and large eyes, they are proportionately smaller than the Cute and Round and Toon Mascot examples. The drawing and coloring is also more elaborate.

Realistic

This example renders the character with a heavy emphasis on anatomic accuracy. The body uses a realistic human frame that incorporates appropriately up-scaled but otherwise largely unmodified rabbit features. Getting real means taking great pains to represent details, including the natural flow of fur over the body, textures on footpads and the exact shape of the eyes.

Human Anatomy

The foundation of every anthropomorphic character is the human body. Therefore, a firm understanding of human anatomy is an important first step to drawing fantastic furries.

The human body is complex, and comes in all shapes and sizes (tall, short, fat, thin and everything between). Luckily, there are proportional guidelines all body types have in common that you can use to ensure a well-proportioned figure drawing. We'll also look at head scale, a method for measuring the body using the size of the head, and gender's impact on body shape.

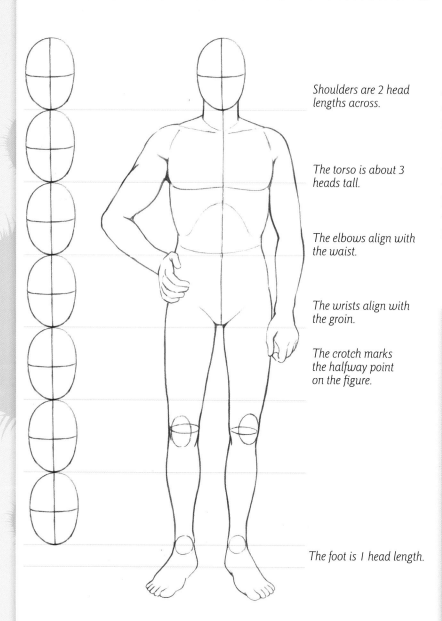

Shoulders are 2 head lengths across.

The torso is about 3 heads tall.

The elbows align with the waist.

The wrists align with the groin.

The crotch marks the halfway point on the figure.

The foot is 1 head length.

Measure With Head Scale

Artists use the head to measure body proportions. The average adult human height is about 7 to 7½ heads. Eight heads is the idealized height for adult figures. Children and teens range from 4 to 6½ heads tall. Fashion illustrators use heights of 9 and even 10 heads to create tall, elegant figures. This figure is 7¼ heads tall.

Try It!

Try drawing some figures with different head to body ratios. The key to keeping the figure proportional regardless of head height is to pay careful attention to the alignment of features and the relative length of one body segment when compared with another. For examples of head scale, take another look at the rabbit anthros. Cute and Round is 2 heads; Toon Mascot is 4 heads; Semirealistic is 6 heads; and Realistic is 8 heads tall.

Gender Differences

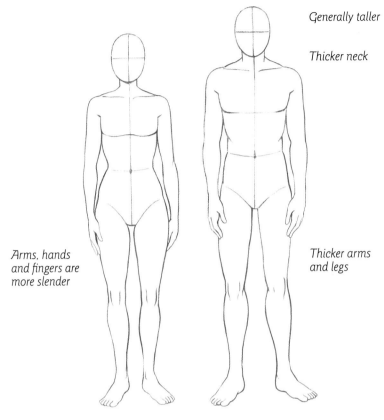

Generally taller

Thicker neck

Arms, hands
and fingers are
more slender

Thicker arms
and legs

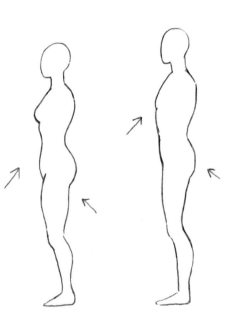

Muscle Mass

Men tend to be more muscular. Capture the hard edges of the male figure by using angular lines.

Women tend to carry more fat on their bodies, giving them a softer shape. Accentuate the roundness of their features using curving lines.

Sideway Comparison

Note the roundness of the female figure compared to the harder edges of the male figure in this side view. The male has a broader chest and flatter stomach and buttocks.

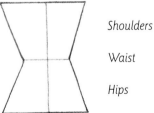

Shoulders

Waist

Hips

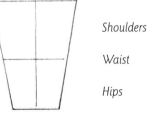

Shoulders

Waist

Hips

Female Torso

In women, the shoulders and hips are about equal width, giving a pronounced hourglass shape.

Male Torso

In men, wide shoulders and narrow hips create a triangular torso shape.

Tools and Materials

You won't need much to start drawing furries. The most important things are a pencil, eraser, some paper, the enthusiasm to draw and a bit of imagination! There are no wrong or right tools for expressing creativity. We recommend starting with the supplies you have readily available around the house and expanding your stock as desired.

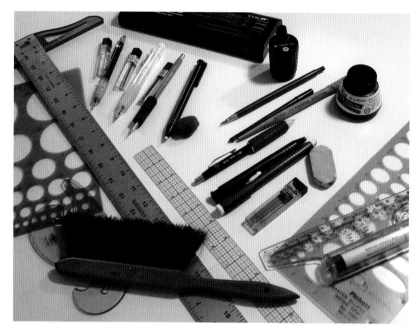

Drawing Supplies

Streamline Your Space

Your workspace should be lit well and comfortable, especially if you plan to spend a lot of time there. We recommend that your setup include the following: a desk with plenty of surface space, a desk lamp (or good overhead lighting) to minimize eyestrain, art supplies within easy reach and an ergonomic chair with good back support.

Drawing Materials Used in This Book:

Pencils
0.5 mechanical pencil
HB pencil lead
2B pencils for sketching
Red and blue graphite for underdrawing and separating details

Paper
Quality drawing paper for finished drawings
General paper for sketching

Erasers
Staedtler Mars plastic eraser for general erasing
Magic Rub eraser for large mistakes
Tuff Stuff Eraser Stick for erasing small details
Kneaded eraser for blending and erasing
Brush for removing eraser crumbs

Rulers and Guides
An assortment of rulers for drawing straight lines
24-inch T-square ruler for drawing horizontal and vertical lines
Circle and ellipse guides
French curves

Miscellaneous
Sketchbook
Thumbtack board for pinning up notes, reference and inspiration
Light box for transferring drawings, creating overlays and checking for mistakes
Figurines for three-dimensional reference
Art and photo books for reference and inspiration
Anatomy charts
Mirror for facial expression and hand reference

Suggested Coloring Materials to Try

Watercolors

Colored Pencils

Oil Pastels and Chalk

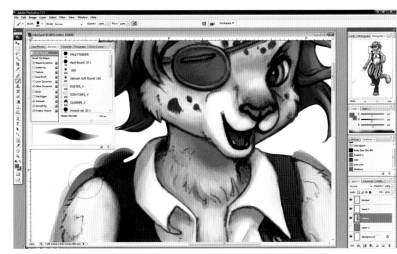

Photoshop®

Coloring Materials

Color mediums come in three forms: wet, dry and digital. Each medium has its own characteristics, so you may find that one is better than another for achieving certain effects. Some are easier to master, but they all require patience and practice to learn. Experiment with different coloring mediums to discover which you enjoy. Most of the artwork in this book was created using digital coloring tools.

Wet Mediums

Acrylic paints
Watercolors
Large brushes for broad strokes
Small brushes for detail work
Paper or canvas appropriate for the medium
Water container
Palette for holding and mixing paint

Dry Mediums

Colored pencils
Markers
Oil pastels
Crayons
Paper appropriate for the medium

Digital

PC with good speed and storage capacity
Adobe® Photoshop® image editing software
Wacom graphics tablet
Scanner

HYENA
The Drawing Process

This first demonstration will introduce you to a systematic approach by taking you through the steps of creating an anthropomorphic hyena, from brainstorming an idea to finished drawing. Don't be discouraged if your first efforts don't match the completed picture. Your results will improve with practice.

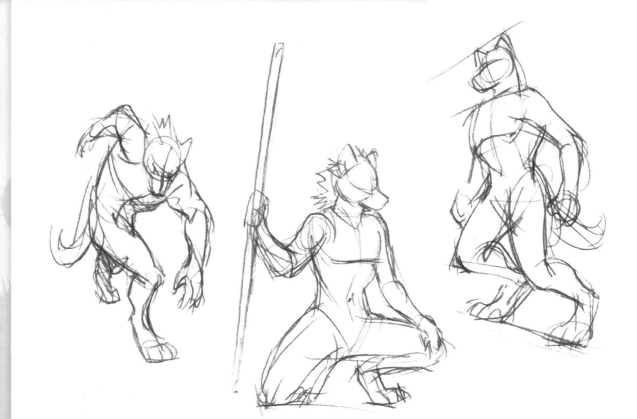

1 *Brainstorm an Idea*
The drawing process starts with the idea, before your pencil touches paper. It's possible to stumble upon a good drawing through random doodling, but having a goal will allow you to focus your efforts into making a great drawing.

Before you start, ask yourself:

Who is the character?

What does he look like?

What is he doing?

Why (his motivation and state of mind)?

The answers to these questions don't necessarily need to be elaborate. For example, for this demo, you'll be drawing a stoic male hyena who is a strong, seasoned tribal warrior (who) on guard for enemy tribes (what) to protect his people from harm (why). As long as your *idea sentence* has a noun and a verb, you're ready to move on to the next step!

2 *Make Thumbnail Sketches*
Sketch poses appropriate for a hyena warrior. It's a good habit to work out your poses at thumbnail size, no larger than an inch or two (a few centimeters), before drawing it full scale. The small size lets you quickly make adjustments and prevents you from over-detailing.

3 Gather Reference

Compile any reference materials required to create your drawing. This might include photos of the animal you're anthropomorphizing, poses, clothing designs, hairstyles and other design elements, as well as physical materials like drapery. Reference imagery can be found in magazines and books (try your local library) and the Internet. For pose reference, ask your friends to model for you or be your own model using a camera and a mirror. One caution: Don't just copy the reference photos. Use your imagination to create the composition, and the photos to help you capture the details.

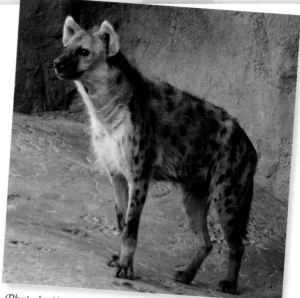

(Photo by Heather Quevedo)

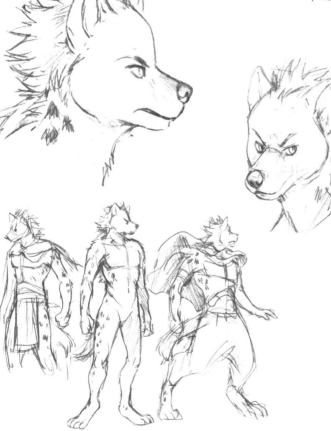

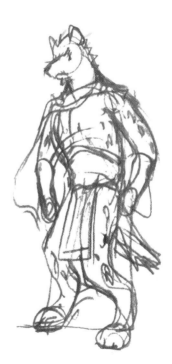

4 Design the Character

Do some exploratory sketches to work out the hyena warrior's appearance, including his face, hairstyle, physical build and outfit. Use reference materials to help you find your design. Think about ways to bring animal qualities in the design. I used the hyena's mane as the inspiration for the character's spiky hair and came up with an open design for the warrior's garb to put the hyena's spots on display.

5 Develop a Rough Concept

Make a thumbnail sketch combining your character design with your selected pose. Although crude, this tiny 3" (8cm) sketch provides the road map for your finished picture. Refer to it as you continue to work through the drawing process.

Think in Shapes

Shapes are the building blocks of art. If you can draw shapes, drawing characters is within your reach.

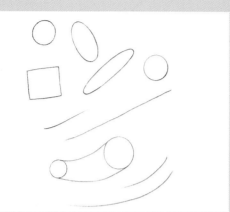

Simple Shapes and Lines
Practice drawing freehand circles, squares, lines and shapes connected by lines. Don't grab a ruler or a circle guide; this exercise isn't about machine-level perfection. Just try to reproduce the forms without excessive sketchiness.

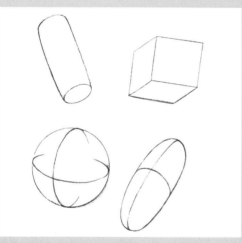

Three-Dimensional Shapes
Once you've mastered the simpler two-dimensional shapes, you can graduate to drawing three-dimensional shapes, like cylinders, spheres and boxes. Using these basic forms, you can draw anything, from cats to skyscrapers, so practice drawing these until they become second nature.

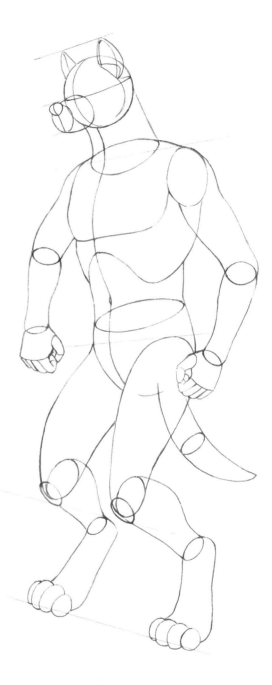

6 *Build up the Form*
Sketching lightly, reconstruct your thumbnail concept sketch using basic shapes. This is the basis of your final draft, so work at full size. Don't worry about the details yet. For now, focus on getting the body shape and proportions right.

7 Sketch the Clothing

Draw the general contours of the clothing over the hyena's body shape. Make sure the clothing conforms to the figure. Give loose-fitting clothing, like the cape and loincloth, some breathing room from the body. Add folds where the clothing hangs or bunches. For fold reference on the cape, drape a sheet on a chair or a friend.

8 Add Details

Now's your chance to have fun with the details. Work your way through the figure, building up the head, musculature, fur, hands, feet and clothing. Refer to your character design sketches for ideas, but don't be afraid to deviate if inspiration strikes. Take special care with the facial features. The face is the focal point of a character drawing.

9 Complete the Drawing

Make one final check over the drawing and darken or refine lines as necessary for clarity. Don't forget to add the hyena's spots. Use an eraser to clean up any guidelines or stray lines. The final drawing should be clean and free of smudges.

Coloring Basics

Color adds extra dimension to art by enhancing mood, defining form, suggesting setting and time of day and conveying surface texture (to name just a few attributes color brings to art). You can also use color to communicate a particular breed or species-type through the coloration of your furry's coat and fur patterns. For this demonstration, we'll walk you through choosing your colors, determining the light source, applying shadows and highlights and finishing touches to bring your characters to colorful clarity.

I color my images digitally using Photoshop®. Keep in mind that coloring techniques vary depending on the coloring medium, so you may need to adjust the process based on the medium you use. What works in Photoshop® may not work in exactly the same way with watercolors or markers.

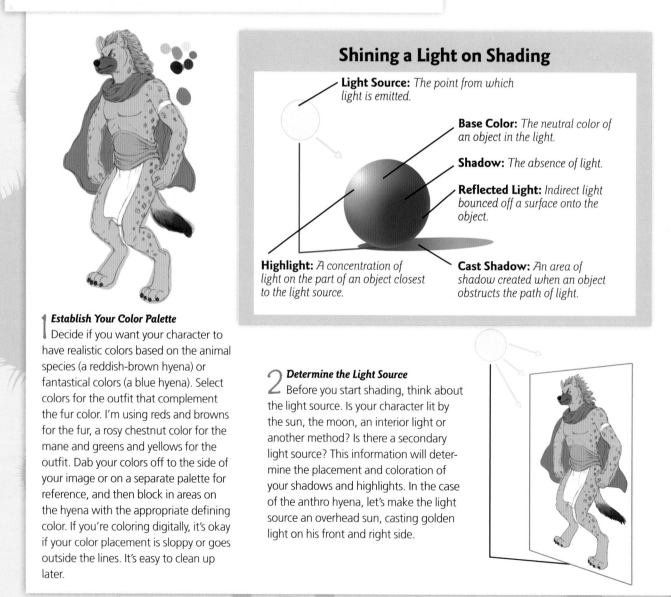

Shining a Light on Shading

Light Source: *The point from which light is emitted.*

Base Color: *The neutral color of an object in the light.*

Shadow: *The absence of light.*

Reflected Light: *Indirect light bounced off a surface onto the object.*

Highlight: *A concentration of light on the part of an object closest to the light source.*

Cast Shadow: *An area of shadow created when an object obstructs the path of light.*

1 *Establish Your Color Palette*
Decide if you want your character to have realistic colors based on the animal species (a reddish-brown hyena) or fantastical colors (a blue hyena). Select colors for the outfit that complement the fur color. I'm using reds and browns for the fur, a rosy chestnut color for the mane and greens and yellows for the outfit. Dab your colors off to the side of your image or on a separate palette for reference, and then block in areas on the hyena with the appropriate defining color. If you're coloring digitally, it's okay if your color placement is sloppy or goes outside the lines. It's easy to clean up later.

2 *Determine the Light Source*
Before you start shading, think about the light source. Is your character lit by the sun, the moon, an interior light or another method? Is there a secondary light source? This information will determine the placement and coloration of your shadows and highlights. In the case of the anthro hyena, let's make the light source an overhead sun, casting golden light on his front and right side.

3 Place Shadows

Select shadow colors that are darker than your base colors. Apply them to areas of the figure not hit by the light source, such as his left side, the creases of the clothing and the underside of his head. Notice how this additional layer of color creates a sense of depth.

4 Build up Highlights

Select a golden-hued color lighter than the base color and use a smaller brush to block in the highlights. Highlights occur wherever the light is most concentrated on the figure. Try not to cover up your base color. Use highlights sparingly, as an accent.

5 Add Finishing Touches

Refine and blend the colors throughout the picture, but be careful not to completely obliterate the brushstrokes. Fill in his spots with a dark brown color. To create the texture of coarse fur, pull some of the base color into the shadow portions using a small-sized brush. Add a hint of red to his fur to give him a warm, energetic glow. Finally, carefully clean up any colors bleeding outside the edges of the character.

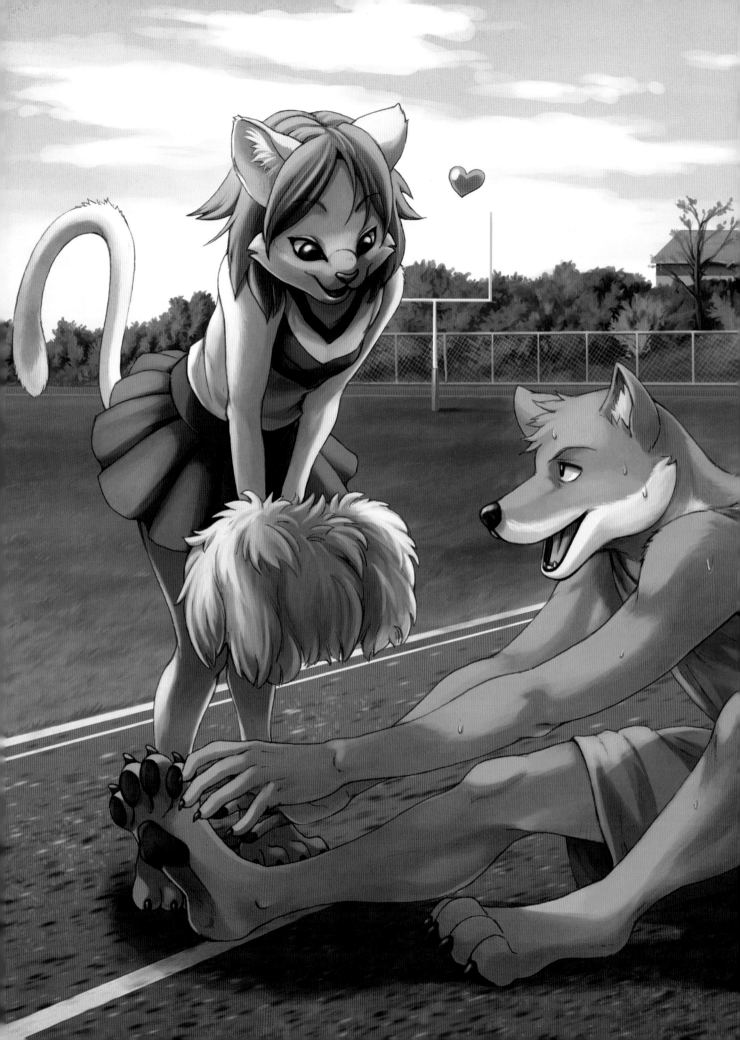

CHAPTER ONE
Drawing Fundamentals

To prepare for the oodles of furry and scaly characters that await you, this chapter provides a quick lesson in character drawing fundamentals. It may be tempting to skip ahead to your favorite animals, but we highly recommend running through the basics first. Imagine you're preparing for a marathon: These lessons are the warm-up stretches that will help you reach the finish line in first place!

You'll start by drawing a simple anthro character to brush up on anatomy and proportions. Next, you'll learn tricks and techniques for drawing furry characters from any angle. Then we'll show you how to harness your character's facial features, ears, tail and even body to express a gamut of emotions. The chapter also comes packed with valuable reference about skeletal and muscular structure, body shapes, posture and balance, anthro leg configurations and dynamic poses to help you power up your figure drawing abilities.

Don't just stand there—grab a pencil, eraser, some paper and get ready, set...GO!

"I start with a basic idea (in this case, an athletic track runner and his cheerleader admirer), and work it out in a series of small thumbnail sketches. I keep sketching until I'm satisfied with the character's poses, expressions, the setting and overall composition. Next, building up from basic shapes, I re-create my favorite thumbnail as a full-sized drawing. Once the forms are solid, I add details and tighten my pencil lines. I scan the finished drawing onto the computer for digital coloring in Photoshop®." —Lindsay

Warm Up
by Lindsay Cibos

Drawing the Head

As a warm-up, let's try drawing the head of an anthropomorphized dog facing front. A straight-on shot is not a particularly exciting angle, but it is useful for learning the proper placement of features or exploring new character designs. The basis for this furry is the Korean Jindo dog breed, which sports a strong muzzle, short fur and upright triangular ears. Take care to bring out these features as you draw him.

Maintaining good symmetry is essential when working with characters facing front. As you work, utilize guidelines to keep features on both sides of the face balanced and periodically look at your drawing in reverse by holding it up to a mirror to check for lopsidedness.

1 Start With a Circle
This is the starting point for any animal head. Your circle need not be perfect, but if you find it difficult to freehand, use a compass or circle guide template for help.

2 Sketch the Crosshairs
Now imagine that the circle you drew is a three-dimensional sphere, rather than a flat object. Draw a vertical line neatly dividing the sphere in two. Then draw a horizontal line cutting across it, slightly curving downward with the spherical shape for the character's eye line. Together, these lines form the crosshairs, which indicate the center of the face, and where the character is facing.

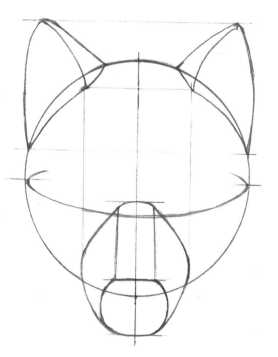

3 Place the Muzzle and the Ears
From slightly above the eye line, sketch the top and front of the muzzle shape, then fill in the sides. It helps to think of the dog's muzzle as a cone shape, extruding from the lower portion of the head. Next, sketch the ear shapes along the top of the head facing slightly outward. Use guidelines to align the ears.

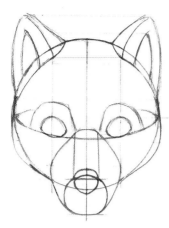 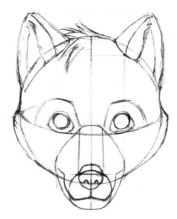 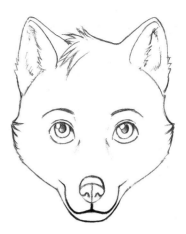

4 Sketch the Facial Features

Draw the almond-shaped eyes along the horizontal eye line, about an eye-sized space apart from each other. Then sketch the brows curving around each eye and down to the muzzle. Next, sketch the nose so it nestles between the top and front sides of the muzzle. Finally, extend out the sides of the face with round cheeks and sketch the general shape of the dog's inner ear fluff.

5 Detail the Face

Fill in the nose with a pair of inward curving lines to form the nostrils. Then draw the softly curving W of the mouth that pulls into a wry smile on the sides. Next, draw the circular irises on the eyes, extending past the eyelids. Finally, using brisk, angular strokes, fluff out the dog's ear and cheek fur and sketch some forward-facing hair tufts at the top of his head for bangs.

6 Refine the Line Work

Darken the brows and fill in the pupils on the eyes. Then, carefully working your way through the picture, erase any guidelines, and tighten your pencil lines as needed.

7 Finish With Color

Use your favorite coloring tools to add an extra dimension to your furry's face. Bring out the texture of the fur using short and quick strokes. Then sit back and admire your finished canine portrait!

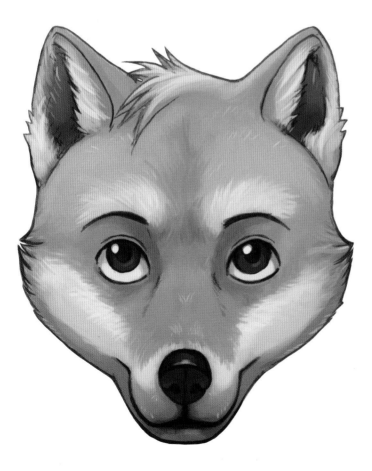

Study the Features

Face shapes vary for each animal. Eyes might sit high above the eye line; ears can droop low. Muzzles can be broad or narrow, long or short, and positioned high or low on the face. Always have reference material of your subject on hand to study and adjust the positioning of the eyes, muzzle, cheeks and ears to suit the animal.

Muzzle Mania

Many artists find the muzzle a challenging area to draw on furries due to the way it juts out from the skull. Luckily, there's a useful tool at your disposal to make drawing muzzles on even the most difficult head angles manageable: the grid system!

The Grid System

Once you have a least one head drawn, you can use grid lines to find the position of facial features from trickier angles.

Use the guidelines to line up landmarks (eyes, nose, ear tips, chin and so on). Features remain in the same position on the grid even as the angle changes.

The first step to drawing any head is to start with a basic sphere, using crosshairs (lines that intersect to create a plus sign) to indicate the character's facial features. Then you can place the eyes, sketch the muzzle shape and build out the rest of the head.

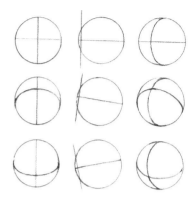

Use the grid to find the proper placement of a canine character's muzzle from the front, side and tilting head angles. If you don't have grid paper, you can achieve the same result by using a ruler to draw horizontal and vertical lines across key features.

The bottom of the eyes and top of the nose on all three heads rest along the same horizontal line.

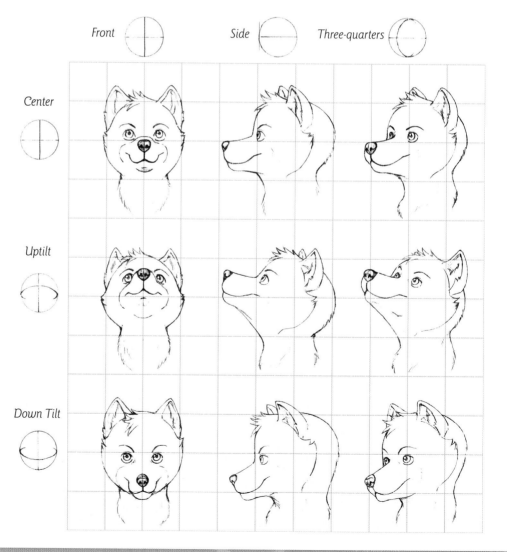

More Head Angles

Practice drawing the back of the head, three-quarters from the back, top of the head and three-quarters down tilt. A trick for drawing the back of the head is to trace the contour lines of the front view and reverse it. Voilà, the outline for the back view!

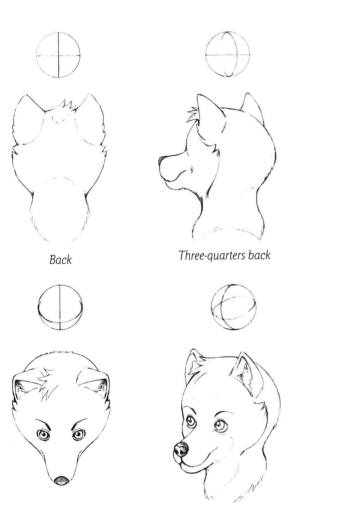

Back

Three-quarters back

Top

Three-quarters down tilt

Muzzle Slope

Canine muzzles generally project straight out or with a subtle slope. Slopes of over 35° are unusual in canines, unless you're drawing a Bull Terrier. The degree of slope depends on the animal, so always check your reference material, and make sure you're looking at the slope of the muzzle, not just a downward tilt of the head.

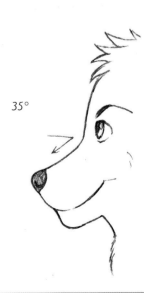

10°

20°

35°

Try It!

Now it's your turn! Draw a character from the front, then use the grid system to draw the character from eight other angles. Remember to draw the underside of the chin and muzzle on upturned heads. Next, try tackling the back view, three-quarters back and top. When you're comfortable with those, try adjusting the placement of the crosshairs on the sphere to create other angles. You can print out this blank grid to get you started at impact-books.com/more-furries.

Facial Expressions

The next step is to learn how to manipulate the character's facial features to express emotion. There's no need to limit yourself to happy and sad. The number of expressions a character is capable of making is practically limitless.

The key areas of the face for communicating emotion are the eyes, brows, mouth and ears. Individually, these elements show a general state of mind. When combined, they can portray complex and nuanced feelings. Let's take a look at how to capture them.

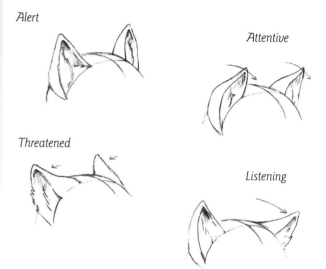

Alert

Attentive

Threatened

Listening

Ears

Some furries have flexible ears, which provide them with an extra nonhuman means of expression. For instance, ears standing erect make the character appear alert. Ears pointing forward indicate attentiveness or an amiable mood. Laid back against the head indicate anger or fright. When only one ear turns, the character is listening to sounds coming from that direction.

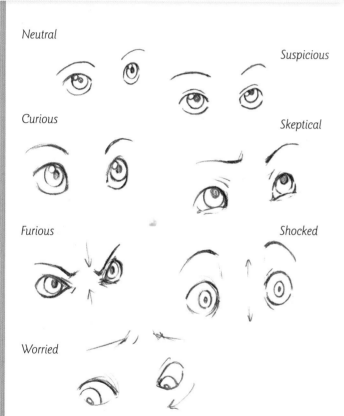

Neutral

Suspicious

Curious

Skeptical

Furious

Shocked

Worried

Eyes and Brows

The eyes and eyebrows work in unison. See how the spacing between the eye and brow changes the expression? They squeeze tight together when serious, angry or in pain. Their distance widens when frightened, confused or surprised. The direction of the eyes also plays a role. Eyes looking back suggest contemplation, while forward-facing eyes show engagement.

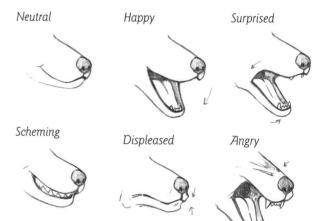

Neutral

Happy

Surprised

Scheming

Displeased

Angry

Mouth

The components at work here are the lips, teeth and jaws. Only the lower jaw moves. The upper jaw is fused with the skull.

Use upward-curving lips to create friendly, approachable faces. When the character is angry, pull back the lips to reveal sharp, threatening fangs. Lips pursed tightly together show displeasure. A toothy smile reads as either grinning or scheming.

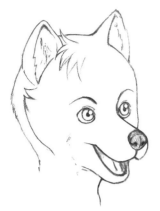

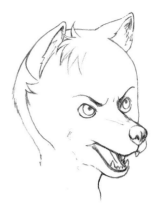

Cheerful
Upright, alert ears, bright eyes and an open, smiling mouth show us he's in a good mood.

Regretful
Pulled-back ears with a downward gaze and slightly raised eyebrows create an expression of inner turmoil.

Provoked
Watch out! All the signs of anger are present: focused gaze, forward pinched ears, lips pulled back in a snarl, lowered eyebrows and flaring nostrils.

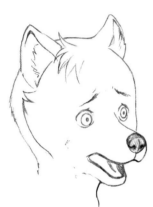

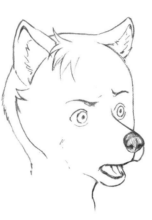

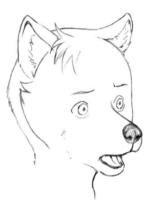

Distressed
Stretching apart the eyes and brow creates a look of panic. Coupled with a gaping mouth and pulled-back ears, it gives the impression that something is deeply troubling him.

Forlorn
The semi-closed eyes can show a relaxed state, but the back-turned ears, upward tilt of the brow and drooping jaw hint that he is bothered.

Incredulous
Surprise can be expressed through a wide-eyed gaze and an open mouth. The slightly uplifted eyebrow and single forward-facing ear hints that he doesn't entirely believe what he's hearing.

Try It!

Practice drawing the above expressions on your character. Then, challenge yourself to draw other expressions, such as embarrassment, grumpiness, confusion and adoration. Make each expression in a mirror so you can see and feel the active elements of the face. Transfer what you see onto your character. Don't forget to take advantage of your furry's ears and teeth for extra expressive oomph!

Drawing the Body

Now, let's give our anthro dog a body! The Jindo breed this character is based on is a moderate-sized dog, so let's make him about the average human height with proportions of seven heads tall. We'll start with a basic standing pose in a three-quarters view. For now, forego the figure-obscuring clothing so you can focus on drawing the body. (Don't worry, a warm layer of fur keeps our au natural furry perfectly comfortable, while a pair of sunglasses and scarf provide fashion flair.)

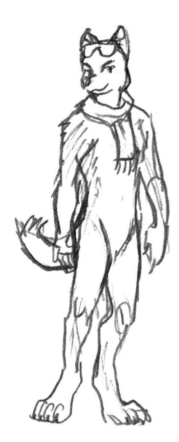

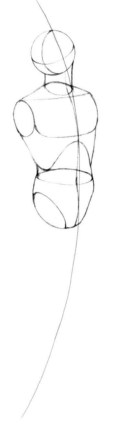

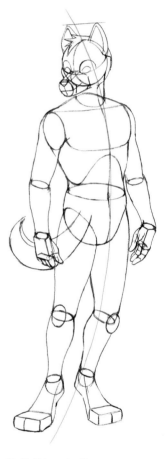

1 Start With the Gesture
Make some gesture sketches of the character in a relaxed, upright stance. A gesture sketch is a quick and loose drawing that captures the essence of a pose. Keep it simple by working small.

2 Sketch the Body Position
Using your gesture sketch as a guide, draw a line of action to establish the flow of action through the pose. Sketch the basic shape of the head and torso along the arcing path of this line. Be mindful of body proportions: On this seven heads tall character, the top of the head to the waistline measures about three head lengths.

3 Build up the Shapes
Sketch the arms, keeping in mind that the elbows align with the waistline and the wrists align with the groin. Then sketch the legs following the line of action. From waistline to heels should be four head lengths. Next, build out the shape of the head using the crosshair guides. Finally, sketch his bushy tail starting from the base of his spine, curving out and upwards like a boomerang.

4 Define the Figure

Build upon the body shapes using a combination of curved and strong angular lines to bring out his muscular male form. Use brisk, angular lines to emphasize the fur on his head, neck, shoulders, elbows, groin, tail and calves. You can further bring out his canine qualities by giving him claws and pads on his fingers and toes. Finally, fill in the details of his face. Erase your guidelines and refine lines as necessary for a clean, finished drawing.

Silhouette Check

You can check the readability of a drawing by tracing the outline and filling it with black. If the pose is strong, the action will still make sense in silhouette. If the figure becomes a confusing blob, look for ways to separate the elements of the body. This might involve pushing out an arm to free it from the torso, or tilting the head to create space between the chin and shoulder.

5 Finish With Color

Add colors to bring out the dimensionality and texture of the figure. You can equip your furry with accessories, like a pair of sunglasses and a scarf. I used a lime green color for the scarf and glasses to contrast the reds and tans of his fur.

Furry Anatomy

Furries don't exist, but their anatomical structure has a basis in reality—a combination of human and animal forms. For the most part, the body is built like a human's, with the exception of the head (muzzle, ears), hands (claws), pelvis (tail) and legs (animal feet).

Familiarity with what's going on underneath the skin is essential to better understand what you're drawing on the surface. A firm grounding in anatomy will show through in your art, bringing to life believable characters who seem ready to leap off the page!

Let's look at an example of furry structure that combines human and canine anatomy.

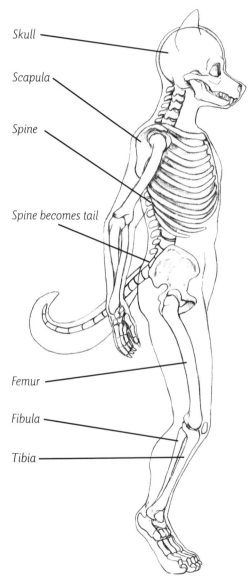

Skull

Scapula

Spine

Spine becomes tail

Femur

Fibula

Tibia

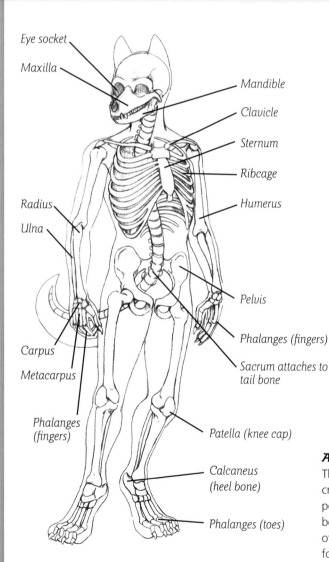

Eye socket

Maxilla

Mandible

Clavicle

Sternum

Ribcage

Humerus

Radius

Ulna

Pelvis

Phalanges (fingers)

Sacrum attaches to tail bone

Carpus

Metacarpus

Phalanges (fingers)

Patella (knee cap)

Calcaneus (heel bone)

Phalanges (toes)

Anthro Dog Skeleton

The skull is a fusion of a canine's jaw bones, with an enlarged cranium for human-sized brain. The coccyx (human tail bone) portion of the pelvis is replaced with a lengthened spine that becomes the tail. Claws extend from the ends of the phalanges of the hands and feet. Note how the heel bone of the canine foot is lifted, placing the weight on the toes.

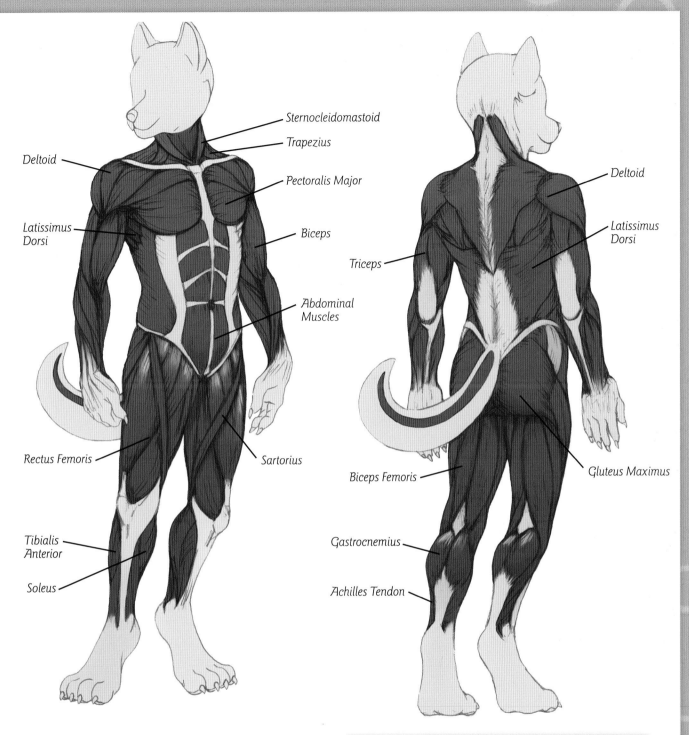

Sternocleidomastoid

Trapezius

Deltoid

Pectoralis Major

Latissimus
Dorsi

Biceps

Abdominal
Muscles

Rectus Femoris

Sartorius

Tibialis
Anterior

Soleus

Triceps

Deltoid

Latissimus
Dorsi

Biceps Femoris

Gluteus Maximus

Gastrocnemius

Achilles Tendon

Anthro Dog Muscles

The dog anthro musculature is nearly identical to a human's, aside from the tail. Study how the muscles determine the shape of the arms, legs and torso. The degree to which the muscles are pronounced will depend on the character's level of fitness and body fat.

The Bones Know

Double-check your work by sketching a simplified skeleton over top of your figure or on tracing paper. Use landmarks like the knees, elbows, ribcage, collarbone, heels and muzzle to properly position the skeleton. If any bones seem misshapen or contorted to fit underneath the surface, adjust accordingly.

Character Turnarounds

A character turnaround shows how a character looks from various angles. It usually includes a front view, back view, side view and three-quarters view.

Drawing a character from multiple angles has practical usage in the professional art field. Animators and comic artists use turn-arounds to establish character designs for reference to ensure consistency in their drawings. These design sheets can also be used to communicate to other artists how to draw the character consistent with the turnaround design.

Get into the habit of doing a character turnaround chart for each of your characters, especially if you plan on drawing the character more than once.

Draw Your Own Anthro Dog
Let's draw a turnaround of our anthro dog. Use horizontal guidelines to line up features of the body from multiple angles. As long as the character's position remains the same, features should always line up, regardless of the direction they are turning. Establish overall height using the ear tips, feet and head. Sketch the number of heads tall the character is off to the side. Use other figure landmarks to keep the character in line at the eyes, shoulders, belly button, knees and heels.

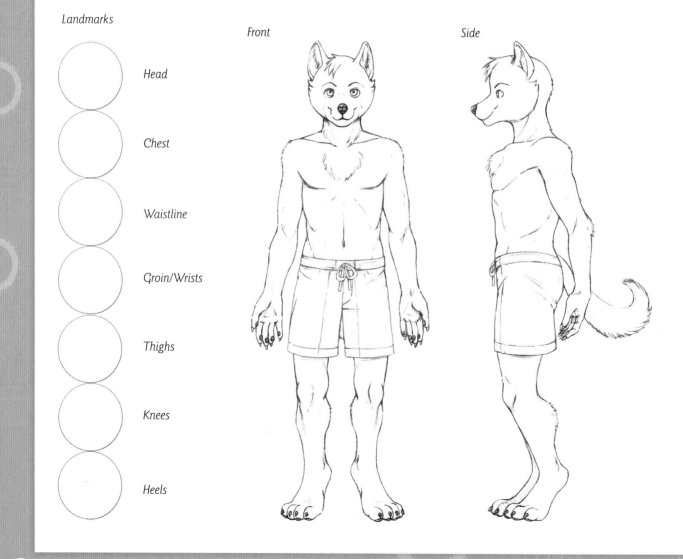

Landmarks

Head

Chest

Waistline

Groin/Wrists

Thighs

Knees

Heels

Front

Side

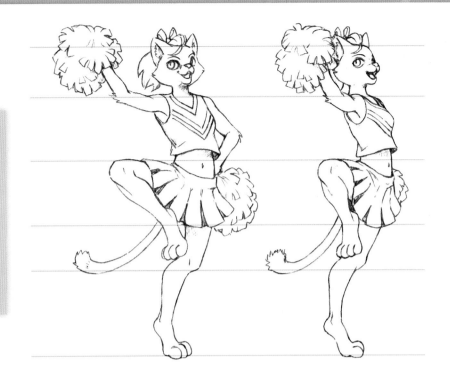

Turnaround Trick

Turnarounds can help you visualize poses from difficult angles. The trick is to draw the pose from an easier angle, and then pull across guidelines from the figure's landmarks to find their placement on the difficult angle.

Back

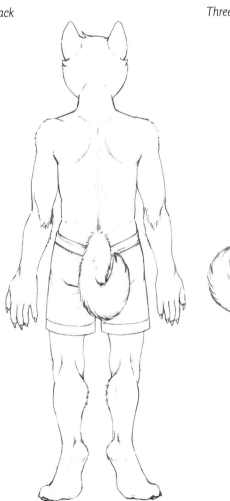

Three-quarters

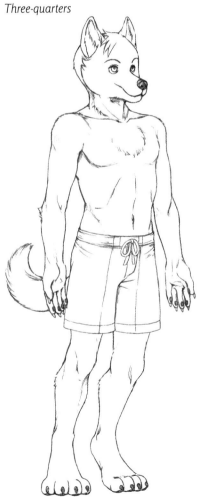

Try It!

Try drawing your own seven-heads tall character turnaround chart with front, back, side and three-quarter views. Pay close attention to lining up the features. Use as many guidelines as you need.

Body Language

You can communicate a character's mood and demeanor nonverbally through their pose. This includes posture, gesture, facial expressions and placement of the hands and tail. Let's take a look at some examples of body language and break down the components that make each pose speak.

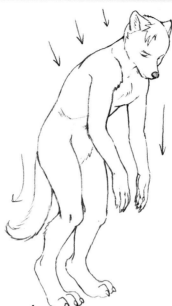

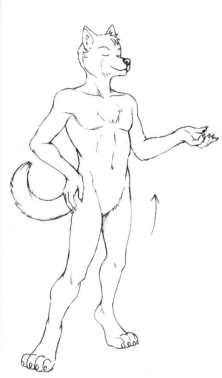

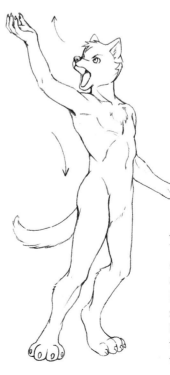

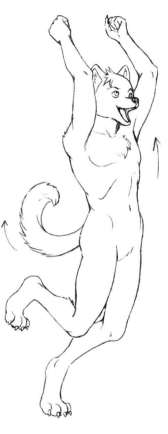

Depressed
Every part of his pose suggests a huge weight pushing down on him. He bows his head, slumps his shoulders and back and lets his arms hang loose. Even his tail hangs limp. He looks utterly drained of energy.

Confident
The open stance, raised head, upright posture and upward curving tail tells us he's feeling comfortable and in control. He uses an outstretched arm to make a point.

Happy
This time he's so upbeat that even gravity can barely keep him down! Everything has an upward and energetic pull. His arms are raised, his tail curves upwards, his back is arched and even a leg is kicking up.

Authoritative
The dramatic gesture and open-mouthed expression suggest he's speaking for an audience. The narrowed eyebrows and back-turned ears suggest he's discussing something serious. The body twisting to the left while an arm pulls to the right creates tension. The arching spine adds strength to the pose.

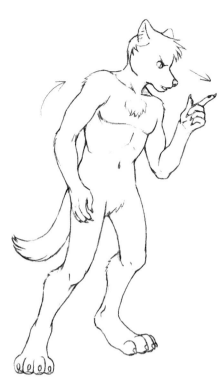

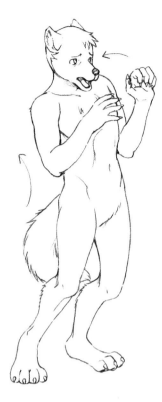

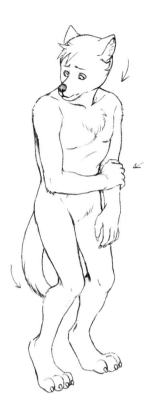

Scolding

The character establishes his dominance by leaning inward. The tension begins at the tips of his toes and travels up his tail, along the spine and finally channels into his glaring eyes and accusatory finger.

Scared

This pose exhibits clear signs of intimidation. He holds his arms out defensively in front of him and leans back to distance himself from the threat. The puffed, downward curving tail and back-turned ears suggest fear.

Ashamed

He pulls all his extremities towards the center, displaying body language that says, "Leave me alone." The downcast glance avoids eye contact, and his hand grasping his other arm and his tucked-away tail show his discomfort. He's not the least bit approachable.

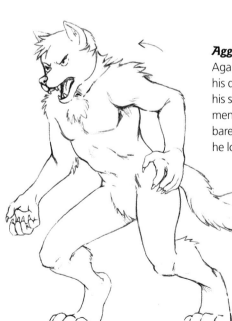

Aggressive

Again, he's leaning forward, displaying his dominance. The bristling fur around his shoulders and tail makes him look menacing. With his crouched stance, bared teeth and grasping clawed hands, he looks ready for a fight.

Speak the Language

You can expand your body language repertoire by observing and sketching people. Malls and cafés are great locations to take a sketchbook and people watch. Movies are a good source for studying complex emotions you might not encounter in everyday life. Also, pay attention to animal emotions. Watch how they use their ears, tails and whole body to express how they're feeling. A great option for both: the zoo!

Posture and Balance

To avoid characters that look off-balance, you need to account for their center of gravity. In standing figures, this is around the center of the chest, but the center of gravity relocates to where the majority of the weight is concentrated when a character leans, crouches or bends over. Pull a vertical line from this point down to the ground. This should align with the weight-bearing foot, or between the feet when the weight is equally distributed.

The shoulders act as a counterbalance to the hips. If the hips tilt up, the shoulders tilt down.

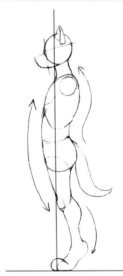

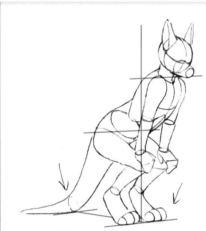

CounterWeight

This kneeling figure distributes her weight between both feet, making her shoulders and hips parallel. Her strong tail provides additional support. By propping her hands on her knees, her upper torso can comfortably lean forward without causing her to lose her balance.

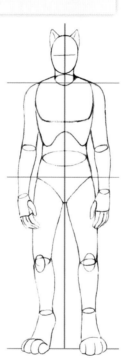

Equal Weight

The center of gravity drops straight down the middle, equally distributing the weight to each leg. The hips and shoulders remain parallel.

Good Posture

In a side view, the middle of his chest is where the center of gravity is located. This aligns with the weight-bearing part of his feet. Also, the natural curvature of the chest and spine counterpoints the raised ankle, helping the figure stay balanced.

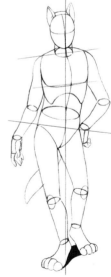

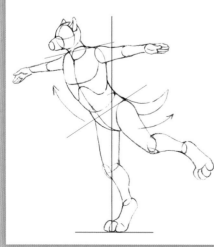

Balancing Act

The center of gravity in a leaning figure shifts away from the center of the chest. He doesn't tip over because the majority of his weight is located above his weight-bearing foot, and is further counterbalanced by his other leg. These poses are trickier. You may need to try the pose yourself and see what's possible.

Weight on One Leg

With most of the weight focused in his right leg, the center of gravity aligns with his right foot. Notice how his hip tilts up with the weight-bearing leg and the right shoulder tilts down to counterbalance. The bust line also matches the tilt of the shoulders.

Leg Configurations

When drawing furries—and animals in general—you'll encounter three types of gaits. You're already familiar with plantigrades, animals that walk on the soles of their feet, like us! There are also digitigrades and unguligrades. There are several ways to approach each leg configuration.

- **Digitigrade**: Walking on toes. The heel never touches the ground. Examples include dogs, cats, birds and dinosaurs. In standing digitigrades, the center of gravity aligns with the toes.
- **Plantigrade:** Walking on the soles of the feet. The center of gravity generally aligns with the middle of the foot unless the character is standing up on tiptoes, or balancing on his heel.
- **Unguligrade**: Walking on hooves. The heel never touches the ground. Examples include deer, cows, horses and pigs. The center of gravity aligns with the hooves.

Backward Knees?

Forget the myth that some animals have backwards knees. The idea stems from a misunderstanding of animal anatomy. What looks like a knee bending backwards is actually the animal's heel! The knee is higher up the leg.

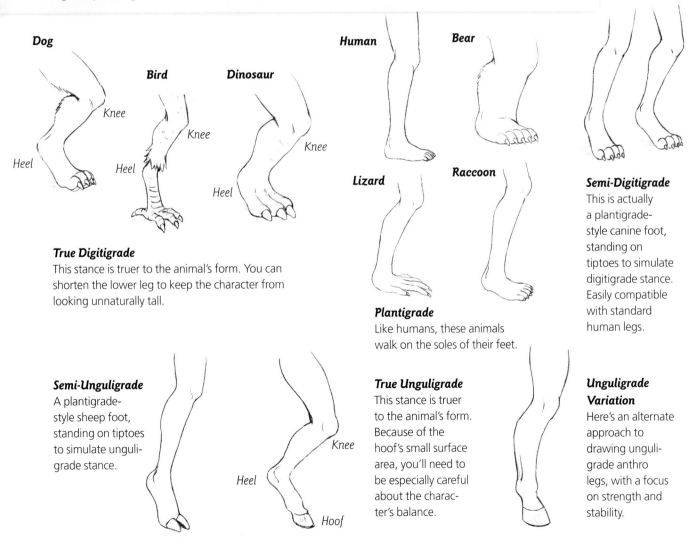

Dog

Knee

Heel

Bird

Knee

Heel

Dinosaur

Knee

Heel

Human

Bear

Lizard

Raccoon

True Digitigrade
This stance is truer to the animal's form. You can shorten the lower leg to keep the character from looking unnaturally tall.

Plantigrade
Like humans, these animals walk on the soles of their feet.

Semi-Digitigrade
This is actually a plantigrade-style canine foot, standing on tiptoes to simulate digitigrade stance. Easily compatible with standard human legs.

Semi-Unguligrade
A plantigrade-style sheep foot, standing on tiptoes to simulate unguligrade stance.

True Unguligrade
This stance is truer to the animal's form. Because of the hoof's small surface area, you'll need to be especially careful about the character's balance.

Knee

Heel

Hoof

Unguligrade Variation
Here's an alternate approach to drawing unguligrade anthro legs, with a focus on strength and stability.

Dynamic Poses

Once you're comfortable with the basics of anatomy, proportion, body language and balance, you're ready to start working dynamic poses into your repertoire. More challenging than static poses, the extra effort will invigorate your art!

What makes a pose dynamic? The key ingredients are action and depth. Enhance the action by twisting the body or pushing the figure past her center of gravity. Utilize foreshortening, perspective and overlap to give the figure a greater sense of depth and form. You won't need to use all of these elements in every picture, but be aware that they are tools at your disposal.

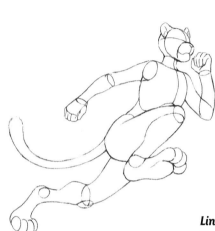

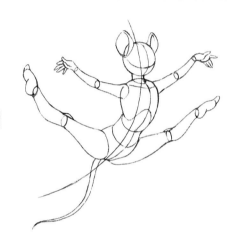

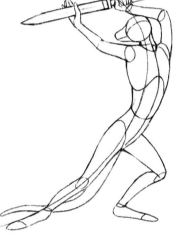

Outside the Center of Gravity
Motion adds dynamism to a pose. To depict actions like walking or running, you'll need to draw the character off-balance by placing their center of gravity in a position where it's unsupported. This is because running (and to a lesser extent, walking) is essentially a figure in a controlled fall, where the runner is constantly catching himself with his other foot.

Line of Action
The *line of action* is used to establish the flow of the primary direction. It's helpful for strong, dynamic poses. This generally takes the form of a curving C or a subtle S. It sometimes follows a character's spine, but not always. Think of it more as a force guiding the action rather than part of the figure.

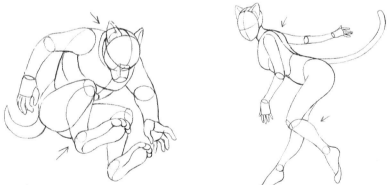

Overlap
Dynamic poses often use *overlap* to create the illusion of depth within an image. Overlap simply means drawing one object in front of another. The brain reads the obscured object as being farther away.

The head and legs overlap the male figure's torso, which suggests these parts are closer to the viewer. Depth cues are also present in the female figure, such as the right shoulder obscured by her torso and the left leg overlapping the right.

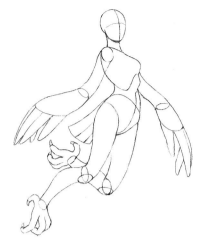

With a Twist

Drawing a figure with a twisting torso is an excellent way to add dynamism to a pose. The opposing force of the hips pulling away from the upper torso suggests motion and depth.

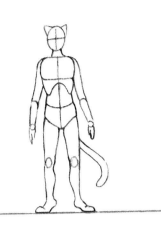

Flat

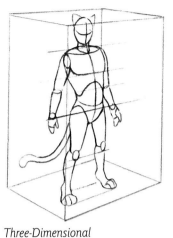

Three-Dimensional

Thinking Inside the Box

Beginner artists have a tendency to treat the edge of the paper, or a horizontal line, as the ground. This results in flat drawings. To avoid this pitfall, draw your characters as though they are standing in a three-dimensional space. An easy way to do this is to lightly draw a box, and then sketch the figure within its confines.

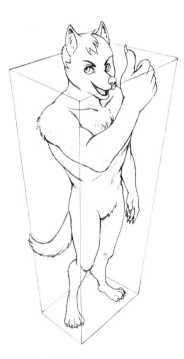

Big Thumbs Up

For help visualizing foreshortened characters, use an exaggerated box shape (with one side much larger than the other) as your starting point. By decreasing the size of his body as it recedes into the distance, the figure dynamically pops out at the viewer. This also uses the overlap to inform the viewer that his arm and head are much closer than the rest of his body.

Foreshortening

Foreshortening is where an object appears to recede into the distance. Because it gives the strong sense of depth, this is a powerful technique for drawing dynamic figures. In this example, the anthro orca's legs and tail are drawn much smaller than her upper torso and head, making it appear like she is swimming towards the viewer.

Body Shapes

Humans and furries alike come in all shapes and sizes. Fat, skinny; tall, short; lean and muscular, just to name a few possibilities. Don't limit your art by falling back on a default body type. A character's body shape can offer clues about their age, level of fitness—even their personality.

Some artists enjoy incorporating animal size characteristics into their furry art (e.g., making an anthro giraffe long and tall, and an anthro mouse extremely tiny), while other artists prefer to keep their furry figures within the range of typical human proportions regardless of species (e.g., drawing the giraffe and mouse at about the same height). Both approaches are equally valid.

Thin
A height of five heads suits this fox, one of the smaller members of the canine family. Her slight frame suggests a youthful age.

Tiny
His cute, two and a half heads tall proportions perfectly capture the diminutive qualities of a mouse.

Fit
Seven heads tall, and three-heads wide at the shoulders; a full-grown figure. His broad shoulders, sturdy torso and thick limbs provide a muscular foundation—necessary for a tough, scavenging hyena.

Cute
At four heads high, the Pomeranian dog is smaller than the fox, with short legs and thick proportions to emphasize her fluffy breed.

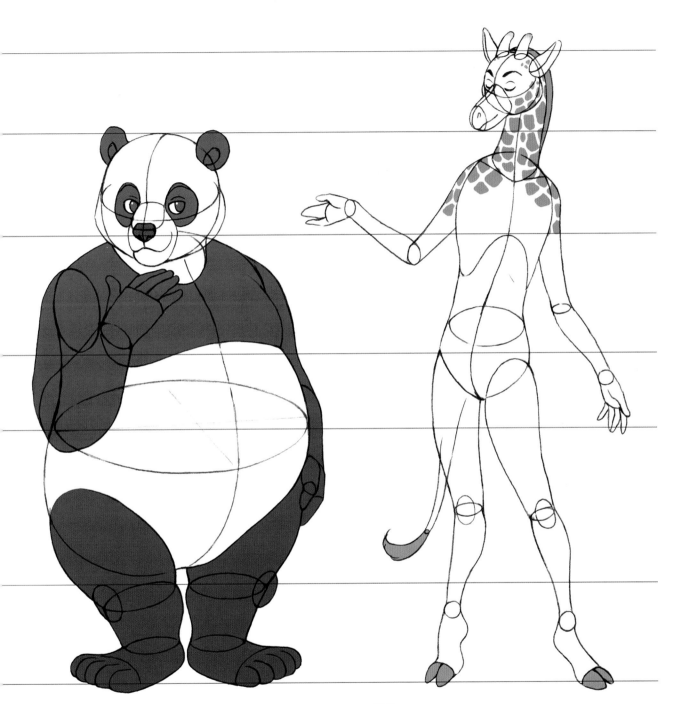

Stout

The panda is only five heads tall, but considering these heads are roughly twice the size of any other character on the chart, it's easy to see why she's so huge. Along with her stature, a barrel-shaped body, wide shoulders and massive arms add to her presence. Large feet support her heavy frame.

Tall

Living up to the giraffe's reputation as the tallest land species, this anthro giraffe is an incredible ten and a half heads high! From the neck, to the torso, to the limbs, every part of his body is elongated. Minimal body width enhances the effect. Despite his stretched proportions, note how his figure still looks proportional because it follows basic guidelines, such as aligning the elbows with the waist and the wrists with the groin.

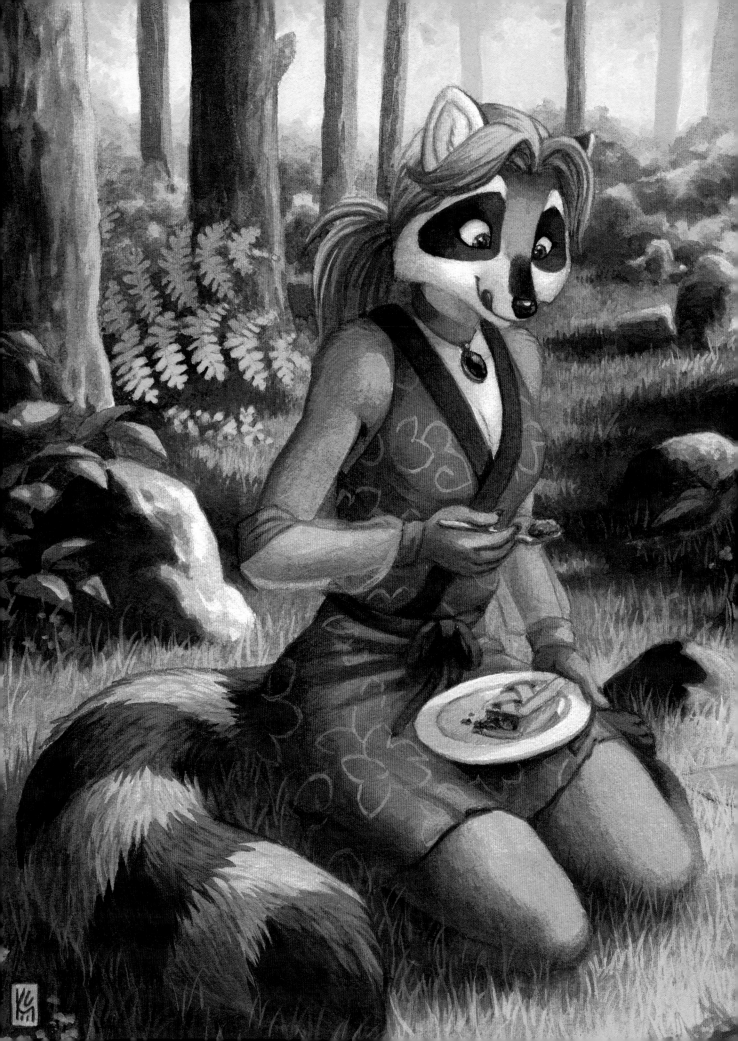

CHAPTER TWO
Furries

It's time to take the drawing fundamentals about anatomy, balance and body types, and apply them to an assortment of animal types. Although the term "furry" pertains to any anthropomorphic animal, this chapter focuses on the mammalian side of furrydom. For each animal, from the hulking bear to the diminutive otter, you're invited to experience the complete step-by-step creation process. We'll start with tips for brainstorming the character design, then move on to building the figure using basic shapes, draping clothing and detailing, and finish with coloring considerations. You'll also learn how to draw specific features, like paws, claws, muzzles and tails to help you get the details *juuust* right.

Without "fur-ther" ado, gather your art supplies and turn the page!

"I work primarily traditionally, my preferred medium for illustration being fluid acrylic paints. Fluid acrylics are a watered-down version of full body acrylics, which behave similarly to both acrylics and watercolors. I start an illustration with one or more simple concept sketches, which I then redraw and refine into a finished pencil sketch on cold-pressed illustration board. Often, I will scan this pencil sketch and do a quick digital color test to determine shadow placement and overall color scheme before committing to the actual painting. Once I begin painting, I will work from the background forward, painting the characters last to make sure they feel unified with their surroundings. A particular focus of mine with character illustrations is to create detailed environments to provide greater context and narrative for the characters." —Kacey

Picnic for One
by Kacey Miyagami

Wolf

As the ancestor of the domestic dog, the wolf is a mix of familiar and bestial, known for viciousness, cunning intellect and pack loyalty. Both revered and feared, wolves are a common subject of folklore, mythology and pop culture. They're also one of most popular animals to anthropomorphize.

Because the wolf shares some physical similarities with dogs, features, such as the paws, ears and muzzle, will be familiar territory if you've been following along.

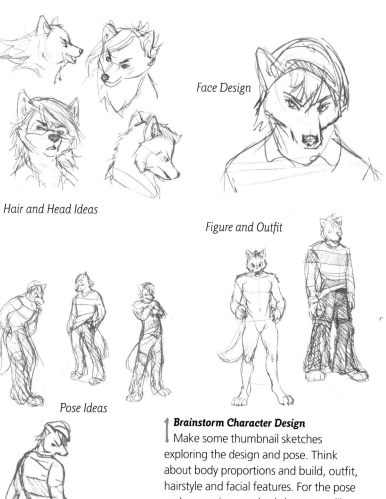

Face Design

Hair and Head Ideas

Figure and Outfit

Pose Ideas

Finalized Design Concept

1 ***Brainstorm Character Design***
Make some thumbnail sketches exploring the design and pose. Think about body proportions and build, outfit, hairstyle and facial features. For the pose and expression, use body language, like crossed arms or an over-the-shoulder scowl, to communicate this character's standoffish temperament.

Now comes the toughest part: settling on a favorite concept. Let's go with the one of him glancing over his shoulder with disdain.

2 ***Sketch the Body Position***
Take your time to draw it full size. On a fresh sheet of paper, sketch a line of action that captures the flow of the thumbnail concept. Use basic shapes to build the head and upper torso along this line. Be mindful of the hip and shoulder tilt.

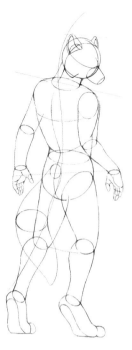

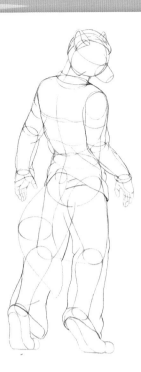

3 Build up the Shapes
Continue building up the rest of the body using basic shapes. Balance the weight of his torso between his legs. Draw his left leg following the line of action and take advantage of his pose to showcase his tail.

4 Sketch the Clothing
Lightly pencil in the basic contour lines of the wolf's pants, shirt and hat. Depict the loose-draping fabric of his pants and sleeves by leaving space between the clothing lines and body contours. Place the waistline of his pants low on his hips to make room for his tail.

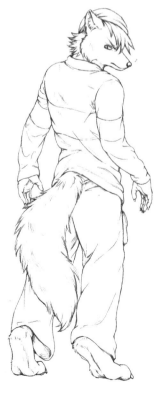

5 Define the Figure
Work through your drawing, adding detail and refining lines. Add more folds and creases to his baggy clothes, especially around the joints, such as the shoulders, elbows, knees, wrists and ankles. Use brisk, angular lines to fluff out his tail, hair, cheek ruff and heel fuzz. Erase your guidelines as you complete each area.

6 Finish With Color
Choose colors for your wolf that suit his cold demeanor and complement his fur colors. Fur colors for wolves range from cream, white, gray, brown and black. I used cool grays and blues for his outfit. As you build up your shadows and highlights, take special care to make his tail look fluffy.

Stylize Your Fur

Some artists prefer to use smooth, unbroken lines for a clean look when drawing fur. This works best with cute cartoon anthros. Other artists prefer to use a series of uniformly jagged lines for a more realistic furry effect. Other techniques involve using a combination of smooth and jagged lines. Notice how each expresses the idea of a fluffy wolf tail in a distinctly different way.

Tail

The tail is a fun and essential element for many anthros. They swish and sway, expressing feelings and adding life and motion to a picture. They can also clue the viewer in to the breed or species of your furry.

This three-step approach to building up the wolf's impressively bushy tail is a useful basis for creating other furry tails, too. Vary the size and shape and adjust the fur and pattern details.

Tail Tip

Even when you're not drawing a furry from the back, it's a good idea to locate the tail's origin point so it looks natural as it sweeps into view.

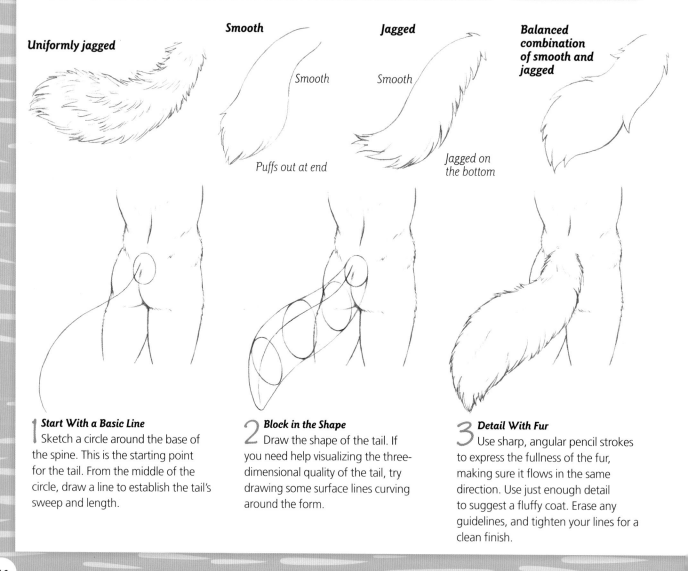

Uniformly jagged

Smooth

Smooth

Puffs out at end

Jagged

Smooth

Jagged on the bottom

Balanced combination of smooth and jagged

1 Start With a Basic Line
Sketch a circle around the base of the spine. This is the starting point for the tail. From the middle of the circle, draw a line to establish the tail's sweep and length.

2 Block in the Shape
Draw the shape of the tail. If you need help visualizing the three-dimensional quality of the tail, try drawing some surface lines curving around the form.

3 Detail With Fur
Use sharp, angular pencil strokes to express the fullness of the fur, making sure it flows in the same direction. Use just enough detail to suggest a fluffy coat. Erase any guidelines, and tighten your lines for a clean finish.

Feet

A wolf foot has four toes and nonretractable claws. Like all canines, wolves stand digitigrade, with their weight focused on their toes and the heels lifted.

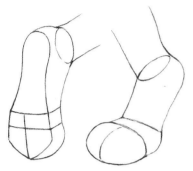 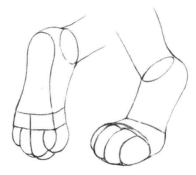 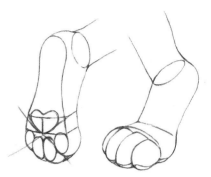

1 Start With a Basic Line
Draw the foot as a rounded rectangle shape attached to the lower leg. Divide the foot into three distinct sections: toes, ball of foot and heel. The heel should not make contact with the ground. Draw a centerline to divide the toe section into two equal parts.

2 Draw the Toes
Further divide the toes into two more parts, so that each foot has four toes. Round out the tops and bottom of the toes. The middle toes should extend past the outside toes.

3 Draw the Toe Pads
Draw an oval-shaped nub under each toe to depict the toe pads. They are slightly visible even from the side view. For help placing the toe pads on the underside of the foot, pinpoint the center of the forefoot and draw an X to divide it into four quadrants. Then, draw the two middle toe pads within the front most quadrant of the X and two more pads at the front of each side quadrant. Finish the pad placement by drawing a heart-shaped foot pad filling the backmost quadrant of the X.

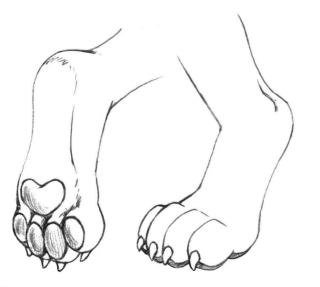

4 Add Claws
Carefully erase your construction lines, and the foot is almost complete. Add a claw to the bottom portion of each toe, pointing towards the center. If you like, add some shading to the pads to give it a rough feel.

My, What Big Ears You Have!

For a tutorial on creating wolf ears, go online to impact-books.com/more-furries. Just drop in your email address for access to a download packed with great information!

FURRIES
Raccoon

With their bandit masks and nocturnal nature, it's easy to cast the resourceful raccoon in the role of a thief. There's nothing wrong with using classic interpretations of an animal's habits or demeanor as inspiration for a new character, but remember that furry characters can act whatever way you choose. Ignoring typecast roles can help your character stand apart.

This raccoon is not the least bit mischievous; rather, she spends her evenings peacefully strolling through the forest, plucking fruit. Though a bit shy, she's always happy to share an apple with any friendly furry who happens across her path.

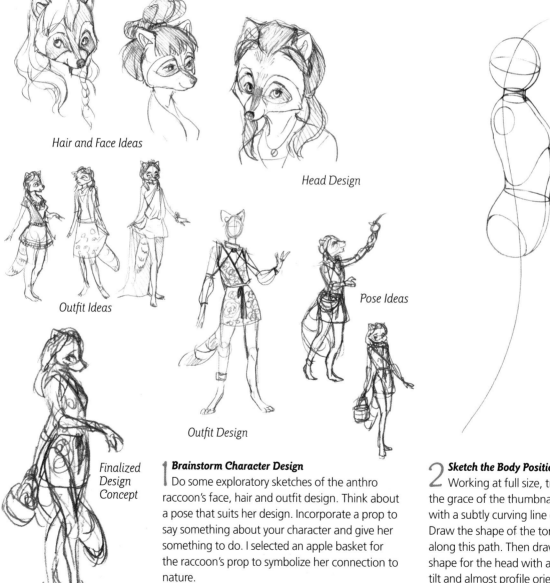

Hair and Face Ideas

Head Design

Outfit Ideas

Outfit Design

Pose Ideas

Finalized Design Concept

1 Brainstorm Character Design
Do some exploratory sketches of the anthro raccoon's face, hair and outfit design. Think about a pose that suits her design. Incorporate a prop to say something about your character and give her something to do. I selected an apple basket for the raccoon's prop to symbolize her connection to nature.

Compile your favorite design elements and pose into a final thumbnail concept.

2 Sketch the Body Position
Working at full size, try to capture the grace of the thumbnail concept with a subtly curving line of action. Draw the shape of the torso and neck along this path. Then draw a circle shape for the head with a downward tilt and almost profile orientation.

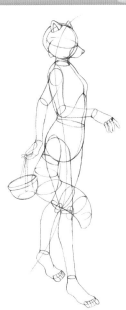

3 Build up the Shapes

Use basic shapes to draw the rest of the figure. Counterbalance the outstretched right arm by swinging the left arm behind the body. Then sketch her right leg stepping in front of her left leg. Raccoons are plantigrade, so draw her with a flat-footed stance. Use the raccoon tail's ringed fur pattern as natural surface lines to help you draw the tail shape. Finally, draw the basic half-circle shape of the basket hanging from her left hand.

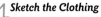

4 Sketch the Clothing

Lightly sketch the basic clothing lines over the shape of the body. For her simple and elegant dress, there isn't a lot of excess fabric, so try to keep the folds minimal. Leave room in the back of the dress for the tail. For the loose hanging sleeves, keep gravity in mind. The heaviest parts will always pull down. Fill the basket with a few apples, spaced apart so they don't look flat.

5 Add Details

Draw the hair pulling around her ears, and tied neatly at the neck. Fluff out her tail and fur pattern with short, broken lines. Fill in the details of her outfit and jewelry. Add a wicker texture to the basket and stems to the apples.

Finally, refine your lines and erase any guidelines.

6 Finish With Color

For the raccoon's fur and hair, I went with a color scheme of rich browns. Use a bright red with a strong highlight to make the apples look juicy and delicious. Fill the dress with a dark color. Then, using a lighter color for contrast, draw a flowery pattern onto her dress. Add shadows and highlights and she's done!

RACCOON FEATURES
Face

The raccoon's defining feature is its mask, so it's worth the effort to draw it correctly. Fortunately, it's not as tricky as it looks. Just approach it one section at a time, and before long, you'll have a pretty anthro raccoon face gazing back at you from your sketchbook.

1 Start With a Circle
Lightly sketch a circle for the head. Then, draw the crosshairs to establish her facing. Position the horizontal line low on the circle to create a downward head tilt.

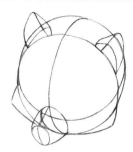

2 Build up the Head Shape
Sketch an angular patch of fur on both sides of the face to form her fuzzy cheeks. Sketch a pair of triangular-shaped ears on the top of the head. Then, starting from slightly above the eye line, draw a rounded cone shape for the muzzle.

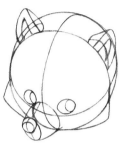

3 Place the Eyes and Nose
Sketch a pair of almond-shaped eyes resting on the horizontal guideline, spaced about an eye's width apart. Draw the eyeballs looking off to the side. Next sketch the raccoon's large, round nose protruding from the tip of the muzzle. Finally, sculpt the inner shape of the ears.

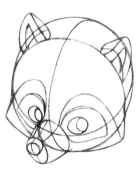

4 Draw the Raccoon Mask
Sketch the part of the mask that encircles the eye. Add an extra line to the upper part to create eyebrows. Next, draw the outer part of the mask across the bridge of the nose and extending to the tips of the cheeks.

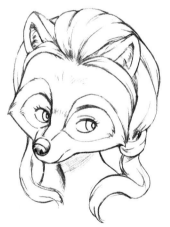

5 Add Details
From the hairline, use graceful curving lines to draw the hair sweeping around the ears into a pair of pigtails. Soften the raccoon's expression by lowering the eyelids with a horizontal line across the eye. Darken the eyebrows and nose. Fill the ears with fur. Add some light hatch lines for fur texture. Erase your guidelines.

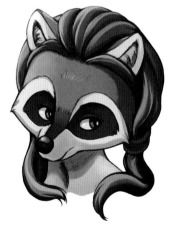

6 Finish With Color
Color the raccoon's face, making the inner part of the mask the darkest portion. Contrast it with a white or cream color for the outer part of the mask. Add a bright highlight to the nose and eyes for a glossy wet look.

Hands

Aside from the fur and claws, raccoon hands are surprisingly similar to our own. They have hairless palms and five fingers, including a thumb (not opposable), which they use to grasp and manipulate objects.

Top side

Palm side

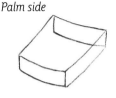

1 Sketch the Basic Box Shape
Use a slightly curved box shape to create the foundation of the hand.

2 Add a Thumb
Draw a wedge shape onto the side of the box to create the lower meaty portion of the thumb.

3 Add the Fingers
Draw four fingers extending from the box shape. Divide each finger into three sections to indicate the joints. Use a curved guideline to line up the segments. Add two sections to the wedge shape to complete the thumb. The thumb comes up to about the second knuckle of the pointer finger, while the pinky aligns with the last joint on the ring finger.

4 Add Details
Erase your guidelines, but try to retain some of the lines indicating the joints. Detail the hands with skin folds and knuckles. Cap each digit with a claw, set deep into the finger.

At Your Fingertips

Hands, with all their moving parts, can be difficult to draw. Fortunately, you always have a helpful model within your reach—your own hands! Refer to them often for reference. Use a mirror for additional angles.

Tiger

The tiger, largest of the big cats, is an impressive and handsome specimen instantly recognizable by its orange-and-white striped coat. Try to capture the strength and ferocity in your anthro tiger by giving him a lean, muscular body, a broad muzzle and piercing eyes.

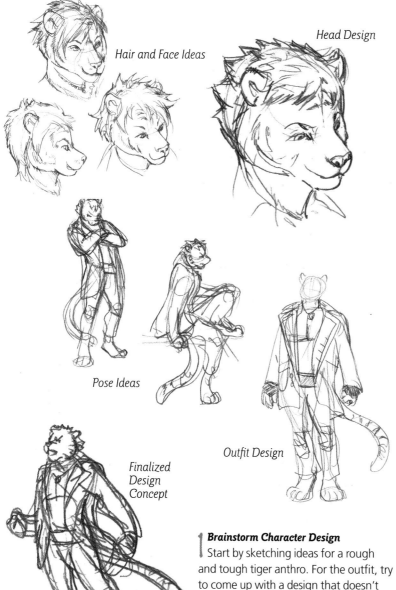

Hair and Face Ideas

Head Design

Pose Ideas

Outfit Design

Finalized Design Concept

1 Brainstorm Character Design
Start by sketching ideas for a rough and tough tiger anthro. For the outfit, try to come up with a design that doesn't obscure the tiger's best features, like his paws, feet and stripes. My solution was fingerless gloves, an open coat and no footwear. Complete the look with some spiky hair and a fierce fighting stance.

2 Sketch the Body Position
Using your thumbnail concept sketch as a guide, rebuild your drawing at full size. Start with a sweeping line of action. Define the tiger's strong upper body by drawing a broad shape for the chest with bulging pectoral muscles. Pinch in the midsection and lower torso. Draw the head shape with a prideful uptilt.

4 Sketch the Clothing

Sketch the basic lines of the outfit. Think about how the clothing wraps around the tiger's form. Draw the coat billowing in the wind to reveal his signature stripes and add motion to drawing. His sleeves and pants are loose fitting, so leave some space around the body lines.

3 Build up the Shapes

Use basic shapes to draw the rest of the figure. For the muzzle, first draw the upper jaw portion then draw the lower jaw pulling down for an open-mouth yell. Draw the arms ending in clenched fists. Following the line of action, construct the left leg fully extended with his ankle held high. Draw the foot digitigrade with meaty tiger toes mashed into the ground.

Finally, sketch the tiger's tail whipping around energetically. Use surface lines on the tail to block in the stripe divisions.

5 Add Details

Work through your picture, elaborating the details of his face, clothing, fur and body. Take advantage of the tiger's fierce fangs to emphasize his angry expression. Darken the inside of the mouth, stripes and tips of his hair with pencil shading. Alternatively, you could use an X to denote areas you wish to darken and fill them in during the coloring stage. When you're done adding details, erase your guidelines.

6 Finish With Color

Select colors for the tiger and his outfit. If you use bright tones like orange and white for his fur, consider balancing them by placing darker colors on other areas, such as the pants. Build up your shadows and highlights to add depth. Place deep shadows in the areas most hidden from the light, like the inside of his coat and under his chin.

TIGER FEATURES
Stripes

The stripes define the tiger. Without them, you'd simply have an oversized orange cat. Stripe thickness, density and placement vary from tiger to tiger. Try to observe some real tigers (or photos of tigers) for inspiration. Stripes mostly occur on the face, back, sides, limbs and ringing around the tail.

1 *Plan the Path*
Build up the character's body as usual—solid anatomy precedes stripe placement. Once the figure is complete, you're ready to start thinking about the stripes. There's no need to actually draw the little arrows, but do make a mental note about the contours of the body. The stripes will follow these contours.

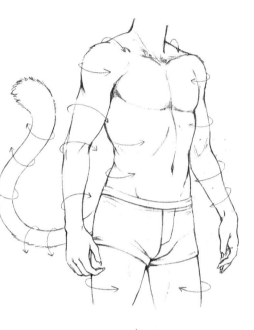

2 *Add Stripes*
Pencil the tiger's stripes along his arms, legs, side and tail using broken, jagged lines. Vary the thickness and length. Curve the stripes around the body's form. Then, color the figure. Fill in the orange and white coat first, and paint in the stripes with a dark brown.

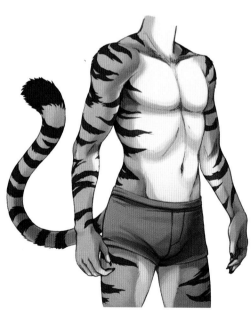

Stripe This Way

For natural looking tiger stripes, stay away from smooth, continuous lines. Use broken lines with jagged edges to keep the stripes organic and unpredictable.

Good
Stripes consist of broken lines and V-shaped patterns that taper from thick to thin.

Bad
Note the even spacing and monotony of the stripes. Avoid this oversimplification, unless that's your goal.

Head

For this demonstration, you'll get to practice drawing a tiger's head from two different angles. As you draw, focus on the tiger's unique facial markings, shaggy cheek ruffs and broad, sloped muzzle.

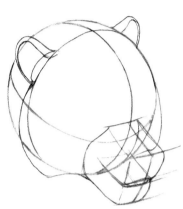
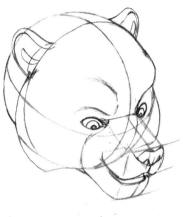
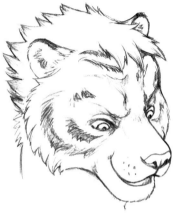

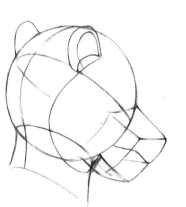
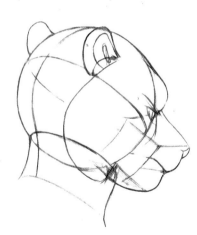

1 Build up the Basic Shapes
Lightly sketch a circle for each head. Use crosshairs to indicate his facing. Let's do a front and back view.

Draw the muzzle (try an open mouth on the front view), ears and cheek shapes. Use guidelines to ensure that the edges of the muzzle and the ears are parallel. Pay close attention to your features placement based on the angle of the head.

2 Sketch the Facial Features
Place the eyes slightly above the horizontal guideline. Add a brow line above the eyes. Then, fill in the inner part of ear shape on the angles where it would be visible. Elaborate on the muzzle with nose and mouth details.

3 Add Details
Give the tiger some wild spiked hair to help humanize him. Next, lightly sketch the pattern for his facial markings and darken them with pencil shading. Add some angular lines to his cheek ruffs and inner ear fur to give them a shaggy, rough quality. Finally, detail the eyes and muzzle areas. Erase any guidelines and he's done!

Kangaroo

The kangaroo is a marsupial, a family of mammals best known for raising their young in a special pouch on their body. In addition to its pouch (ladies only), other notable qualities of the 'roo are its strong legs, large feet and long muscular tail used for balance. Emphasize these features in your anthro kangaroo.

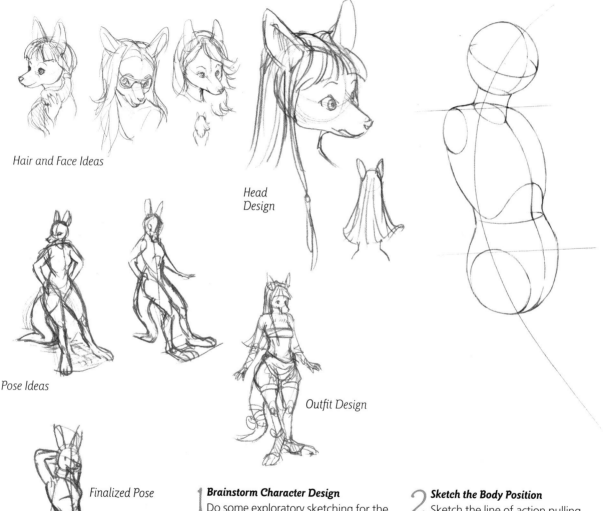

Hair and Face Ideas

Head Design

Pose Ideas

Outfit Design

Finalized Pose

1 Brainstorm Character Design
Do some exploratory sketching for the kangaroo's design, clothing and pose. Fashion and hair magazines are a great source of inspiration for hairstyles. For the outfit, I gave her puffy shorts to complement her thick muscular legs and an apron to symbolize a kangaroo's pouch. For the pose, incorporate the kangaroo's tail as an extra balancing point to create fun poses that only a kangaroo could pull off.

2 Sketch the Body Position
Sketch the line of action pulling heavily to the left to establish the character's leaning stance. Then, draw the head and torso shapes along this path. With her weight distributed equally between her feet and tail, draw the shoulders and hips parallel to each other. Use guidelines to help align them.

3 Build up the Shapes

Sketch the muzzle, ears and cheeks to complete the basic shape of her head, then move onto the legs and tail. Approach these as essential parts of a tripod with equal importance in bearing the 'roo's weight. Crook the tail like a spring underneath her body mass to emphasize its role in supporting her weight. Finally, draw the arms clasping behind her head, hiding the hands, to keep the focus on her unique kangaroo balance.

4 Sketch the Clothing

Draw the basic form of her outfit with minimal detail. Go with a slouchy apron around her waist to play the role of a kangaroo's pouch, or draw a realistic kangaroo pouch in its place, if you prefer. Note how the open design of the footwear adds visual interest without obscuring her kangaroo toes.

6 Finish With Color

Despite the red kangaroo's name, only the males of the species have red-brown fur. The females are usually more of a blue-gray coloration. Use brighter blues for a playful interpretation. After filling in the base colors, build up the shadows and highlights to finish your 'roo.

5 Add Details

Complete the kangaroo's face by drawing the eyes, nose, mouth and inner ear details. Use long, graceful lines to express the flow of her hair. Add folds to the clothing to emphasize the puffiness of the pants and apron, and the tightness of the top and ribbons. Use small broken lines to indicate a different-colored patch of fur along her stomach and chest. Tighten up the rest of your lines and erase any guidelines to complete the drawing.

Kangaroo Features

Tail

The kangaroo's springy tail is strong and flexible. It serves as a functional fifth appendage, helping with balance and steering when the kangaroo is in motion and stabilizing when at rest.

Stance

The kangaroo is built for hopping, with thick muscular thighs and slender lower legs. In motion, they bounce on the tips of their toes, but at rest, they stand with their feet firmly on the ground the same as any other plantigrade animal.

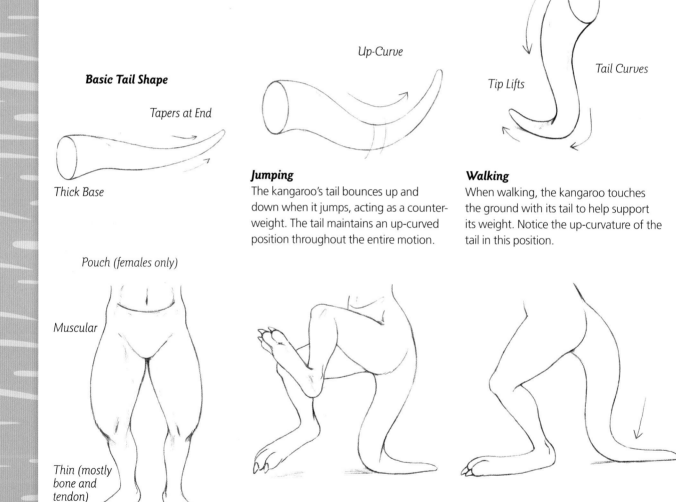

Basic Tail Shape

Tapers at End

Thick Base

Up-Curve

Jumping
The kangaroo's tail bounces up and down when it jumps, acting as a counter-weight. The tail maintains an up-curved position throughout the entire motion.

Tip Lifts

Tail Curves

Walking
When walking, the kangaroo touches the ground with its tail to help support its weight. Notice the up-curvature of the tail in this position.

Pouch (females only)

Muscular

Thin (mostly bone and tendon)

Plantigrade

Kicking Kangaroo
The tail is so strong that it can even support the body while both legs are kicking.

Balanced Body
The tail acts as a base for extra support when the kangaroo is standing or sitting. When the kangaroo stands still, the tail flattens against the ground.

Feet

The red kangaroo has long feet with four clawed toes. The largest toe is in the center, with a medium-sized toe on the outside of the foot, and a small inner-most digit that's actually the two remaining toes fused together. On a real kanga-roo, the tiny fused toes end in two small claws, but for this interpretation, we've simplified the anthro kangaroo's foot by omitting a claw and enlarging the inner toe for a clean, symmetrical look.

1 Draw the Basic Shape
Sketch a long, rounded rectangle to form the shape of the foot. Add a curved section to the end of it for the toes. Finally, draw a line down the center of the foot to create a helpful guide.

2 Draw the Toes
Divide the front section of the foot into three toes. Make the middle toe longer than the two outer toes. Draw a small bump above the heel to represent the ankle.

3 Draw the Claws
Draw a long thick claw extending from the end of each toe. Add some light shading to the claws to give them a lacquered quality. Finally, erase your guidelines to complete the foot.

Spring Step
The kangaroo's heel lifts slightly when in motion, just like the human foot.

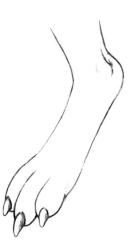

Incorrect

It's fun to draw furries with a digitigrade stance, but make sure it's appropriate for the animal. Avoid giving your anthro kangaroo digitigrade legs like this. Their feet aren't built for it.

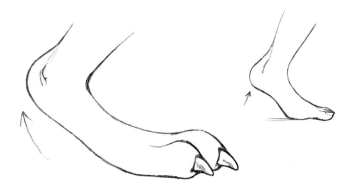

Bear

Weighing in at 850 pounds (386 kilograms) and armed with long claws and sharp teeth, the grizzly bear is an impressive figure of strength. The bear's head is quite broad, almost oval shaped, with deep set eyes, a pronounced brow and a wide muzzle. But don't be fooled by this anthro bear's gruff exterior. He's capable of playing the role of both ferocious fighter and cuddly teddy bear, depending on his mood. You might not want to be on the receiving end of one of his bear hugs right now, though!

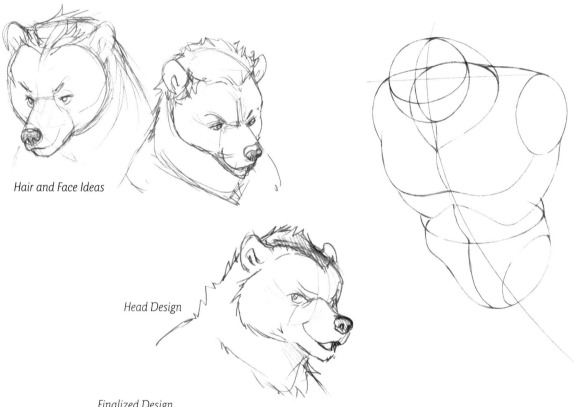

Hair and Face Ideas

Head Design

Finalized Design and Pose

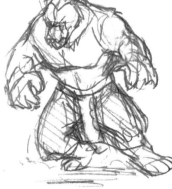

1 Brainstorm Character Design
Start by sketching face and hair style ideas for your anthro bear. Use short, spiked hair to give him a gruff, masculine look that complements his facial shape. For the bear's body, exaggerate the shoulder width, hand size and musculature to create an intimidating form. Bring the design together in a thumbnail sketch of his pose and outfit.

2 Sketch the Body Position
Identify where the line of action is in your thumbnail sketch, and sketch it full size. Build up the torso shape along this line's arc. Draw the chest and shoulder area especially wide across to bring out the bear's massively muscular form. Then, draw a small circle for the head and attach it to the upper torso with a thick neck.

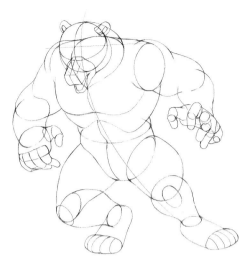

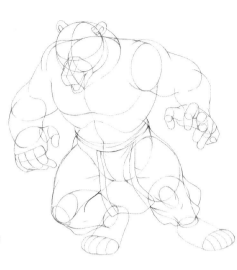

4 Sketch the Clothing
Lightly sketch a pair of loose fighting pants over the bear's hulking form. Keep the detail and folds at a minimum for now. Focus on creating a sense of movement to the fabric.

3 Build up the Shapes
Continue building up the bear's form with an emphasis on bulkiness. Draw the arms thick and muscular with large grasping hands. Draw the stocky legs with a slight bend at the knees, like he's preparing to lunge forward at an opponent. Bears are plantigrade, so draw his left foot planted firmly on the ground while the right pushes off. Finally, add to the shape of his head with muzzle, ears and cheeks.

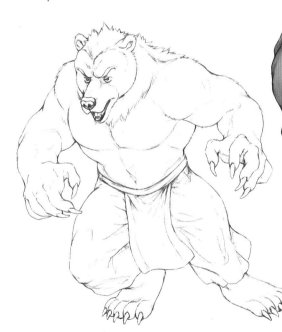

5 Add Details
Detail your anthro bear's face with a nose, a menacing pair of beady eyes and a growling, open mouth. Add long claws to his fingers and toes. Use short, angular lines to build up the fur on the bear's head, back and neck. You can suggest a texture of fur over the rest of his body with light hatching lines (sets of 2–5 parallel lines spaced closely together). Elaborate on his outfit with additional fold lines. Erase any guidelines.

6 Finish With Color
Select colors for your bear's clothes and fur. Grizzly bear fur ranges from blonde to black; brown is the most common, hence, they're also commonly called brown bears. Use short, angular brushstrokes to suggest fur texture. Add shadows and highlights and then sit back and admire your finished creation!

BEAR FEATURES
Grasping Paw

Built for hunting, a grizzly bear's paws are massive and strong. Each of their five fingers is equipped with a curved claw that can grow as long as four inches (more than any other species of bear). The palm side of the paw is padded.

1 Draw the Basic Shape
Sketch a soft box shape for the bear's open palm. Attach a tube shape to the bottom side of it to form the wrist.

2 Draw the Thumb
Form the meaty base of the thumb by drawing a wedge shape. Add two more cylinder segments to complete the shape. The full length of the thumb should only barely reach past the palm.

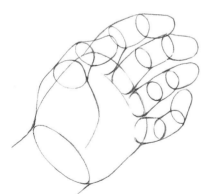

3 Draw the Fingers
Continue drawing the rest of fingers, each slightly bent towards the center in a grasping position. Draw each finger in three segments. Where each segment meets represents a joint where the fingers to bend.

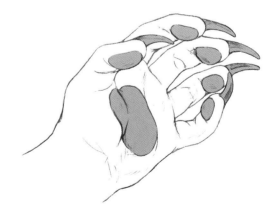

4 Detail With Claws and Pads
Draw a circular pad on each of the fingertips. In the middle of the palm, draw a large, oval pad. Add a long, curved claw extending from the end of each finger. Finally, clean up your guidelines, then add some shading and hatching lines for texture if you like.

FIND OUR DEMONSTRATION ON DRAWING BEAR FEET ONLINE AT IMPACT-BOOKS.COM/MORE-FURRIES.

BEAR FEATURES
Nose

The bear depends on its highly developed sense of smell to forage for food and sniff out threats. As its most important sense, we owe it to our anthro bear to draw its big sniffer properly. Here are some tips.

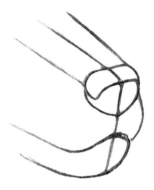

1 Position the Nose
Draw the bear's muzzle with a slight inward slant on the front and a broad nose bridge. Then sketch the nose as a simple rounded shape at the end of the muzzle. Align the top side of the nose with the top side of the muzzle.

2 Refine the Shape
Pull the sides of the nose inward to create the nostrils.

3 Complete the Shape
Next, draw the bottom of the nose, curving around the upper portion. Use pencil shading to express the cavernous inner nostril area.

4 Add Shading
Continue shading the nose to bring out its full three-dimensional quality. Add a highlight on top to suggest a moist, shiny surface (as bear noses often are).

Getting Nosy

The front of the nose looks a bit like a sliced mushroom.

From a side view, notice how the nose fits neatly into the muzzle shape. The front part of the nose slightly extends out from the muzzle.

Otter

Like other members of the weasel family, otters are plantigrade, have long, sleek bodies and small round ears. Although known for their love of play, this anthro otter is taking a small respite to enjoy the soothing sounds of the ocean as she gazes at a pearl from an oyster she found.

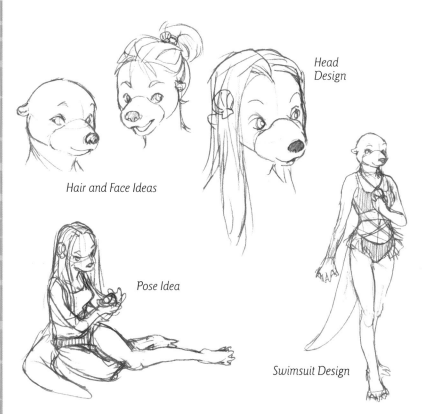

Head Design

Hair and Face Ideas

Pose Idea

Swimsuit Design

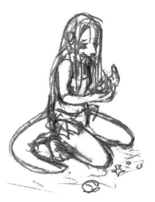

Finalized Design and Pose

1 Brainstorm Character Design
Do some exploratory sketches of the anthro otter's design, including hair, face, outfit and proportions. To create a contemplative scene for this character, try a seated or kneeling pose. You can make a stationary pose more interesting by showing the character doing something. The otter could be examining an oyster or a seashell she found. Or perhaps gazing into a seashell-shaped locket containing a precious memory. Sketch a couple variations and pick your favorite.

2 Sketch the Body Position
Make a line of action in the direction of the otter girl's slight forward lean. Draw the shape of the torso, long and slender, like the streamlined physique of an otter. Then draw a round ball shape with a downward tilt for the head.

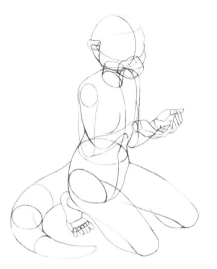

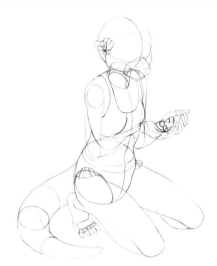

3 Build up the Shapes

Add to the shape of the head with a broad muzzle and small ears. Sketch the arms pulling close to the body. Try to create a clear space between the cupped hands and her face—this is the focal point of the drawing, where the main action (looking at the shell) is occurring. Sketch the legs folding under her in a kneeling position. Finally, draw the thick otter tail sweeping around the body.

4 Sketch the Clothing

Sketch the contour lines of the otter's bikini. Refer to your swimsuit design sketches from the brainstorming step for inspiration. Add some ruffles at the hips for a playful and cute detail. Then, draw the shape of the shell resting in her cupped hands.

5 Add Details

Work your way through your drawing, adding details and erasing any guidelines. Render the otter's sleek fur using mostly smooth lines, and the occasional hatching mark. Detail her face with thick-lashed, downcast eyes, eyebrows and a large nose. Then indicate the fur color division around her muzzle. Use controlled, flowing lines to draw her long hair. Add small claws (and webbing where visible) to her hands and feet. When you're done, add a few seashells to the ground for atmosphere.

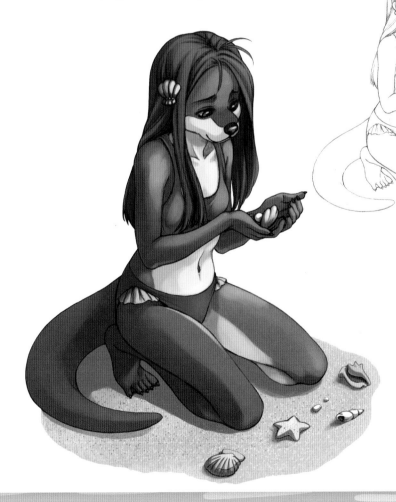

6 Finish With Color

Decide on a color scheme for your otter. I used steel blue for the swimsuit to go with her brown and creamy yellow fur. These colors are a muted variation of blue and orange, which are complementary colors, meaning opposite hues on the color wheel. Used in moderation, they go well together. Next, build up your shadows and highlights to give her a three-dimensional presence. You can create the impression of the beach by painting some grainy sand beneath her (don't forget to add a drop shadow to ground her in the scene).

OTTER FEATURES
Webbed Hands

The otter's hands and feet have webbing between each of their five digits, a great adaptation considering their semiaquatic lifestyle. Let's try drawing the anthro otter's hand with her fingers spread to show the webbing. Hands can be difficult to draw. For help, try posing your own hand to see how the fingers bend and fold in a three-dimensional space.

1 Draw the Basic Shape
Start by sketching a rectangular box for the palm.

2 Draw the Thumb
Draw a wedge extending past the palm to create the muscular base of the thumb. Add two segments to the wedge to complete the thumb shape.

3 Draw the Fingers
Sketch the fingers pulling away from the thumb in a curved position. Build up each finger in three segments to depict the knuckles. Since you're drawing a female otter's hand, try to keep the fingers thin and graceful. Women's hands tend to be more slender and soft than men's.

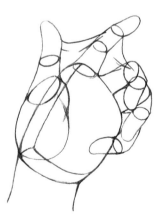
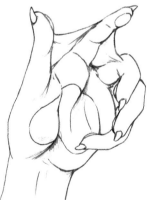

4 Add Webbing
Add webbing between each of the otter's digits, up to the last knuckle. Draw some stretch lines between the thumb and pointer, where the membrane is especially taut due to the distance between the fingers.

5 Finish With Claws and Pads
Scrunch up the palm of the hand with some folds and shading. Draw a round pad on each of the fingertips. Then draw a wider pad on the palm, bending with the curvature of the surface. Next, add a short claw to the end of the each digit. Clean up your guidelines, and you're done!

A Claw Tip

The claw is a continuation of the animal's finger bone. Draw the claw so that its embedded into the skin. Otherwise, it will appear flat.

Right Wrong

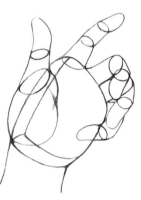

Head

The otter's head is compact and ball-like with a wide muzzle filling a large part of the shape. Pay attention to the relative size of the otter's facial features (small ears, large nose) to capture its impish, cute looks.

Although fun to style, anthro characters don't necessarily require hair on their head. In the case of the otter, a more natural appearance is sometimes preferred. The lack of hair can enhance the otter's streamlined look, like a swimmer wearing a swim cap.

1 Sketch a Circle
Draw a circle with crosshairs to indicate the otter's facing. Try a two-thirds angle with a slight up tilt for this head.

2 Draw the Muzzle
Sketch the bulbous shape of the muzzle, stretching wide across the face. Extend the top of the muzzle above the eye line.

3 Add Facial Features
Draw the shape of the eyes along the horizontal guideline. Above the eyes, dash a pair of abbreviated eyebrows. Draw the ears low on the otter's head, along the horizontal line behind the cheek. At the end of the muzzle, add a large round nose.

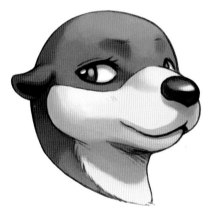

4 Detail and Color
Form the otter's thick neck by pulling a line down from the back of her head and another from beneath her chin. Detail the eyes with a black pupil, a circular highlight and some eyelashes. Tighten your lines, add some hatched lines for texture and erase any guidelines. Then select some colors (I reused my anthro otter's color palette of red-brown, yellow and indigo). Refine with shadows and highlights to finish the portrait.

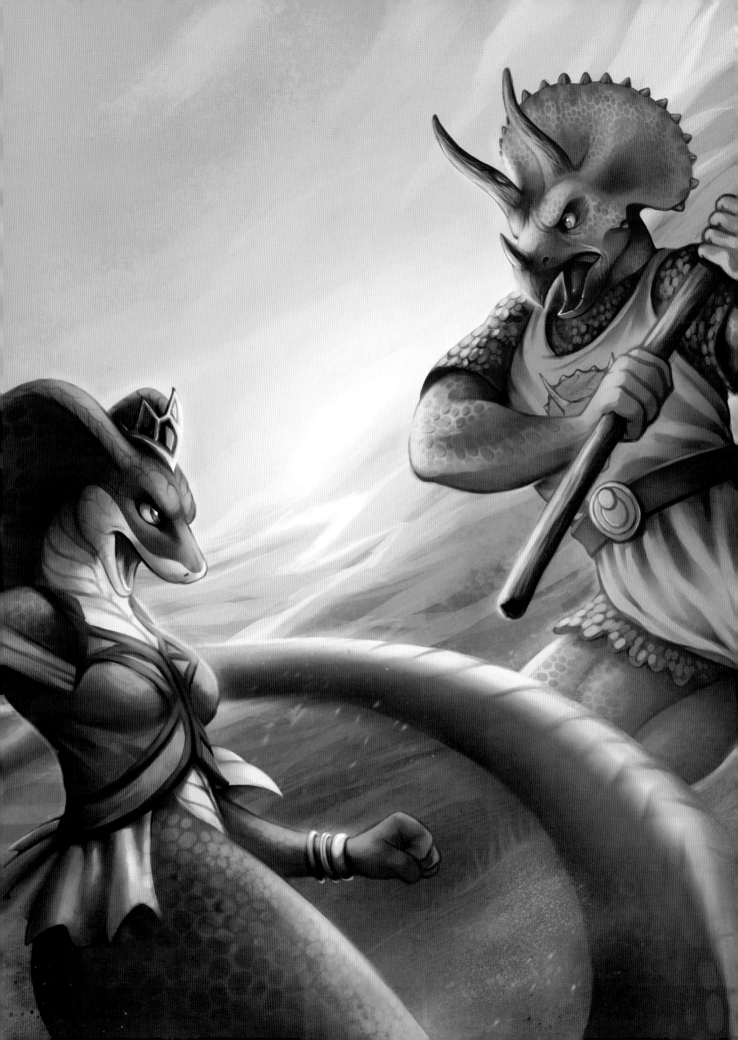

CHAPTER THREE
Scalies

Scalies! As you probably guessed from the name, scalies are anthropomorphic reptiles and amphibians, typically covered with scales instead of fur. Sure, they're not as cuddly as their furry friends, but they are just as fun to draw. This chapter covers a wide variety of scalies: lizards, snakes, crocodiles, frogs and even a few prehistoric surprises! We'll walk you through the process of creating six unique scalies from concept sketch to the finished color art. After each animal, step-by-step feature tutorials cover topics, such as alternatives for hair, jaws, claws, reptilian muzzles, scales and more, to help you perfect your scaly masterpieces.

So slither over to your sketchbook—it's scaly time!

"I'm a female illustrator and designer from Germany. I've always been pretty creative and enjoy not only drawing but many other activities like crafting, photography and design. Now I'm a professionally trained media designer and I have a bachelor's degree in design. For my digitally drawn pictures, I use Photoshop® for both the sketches and coloration. I start with basic flat colors, then I add the shadows and highlights and continue with the details after that. At the end, I make any necessary color corrections to give the picture a balanced look." —Nimrais

Serpent Versus Saurian
by Nimrais

SCALIES
Iguana

This brightly colored green iguana is quite a divergence from the furries we've worked with already. Instead of fur, rigid overlapping scales ranging in size and color protect his body from harm. A row of spines run from his head to his tail and a loose flap of skin, called a dewlap, hangs from his chin. Despite the external differences, the structure under his shimmering scales is still humanoid, so you'll be able to build upon what you've already learned to create a fantastic anthro iguana. Let's do it!

Head Designs

Outfit Design

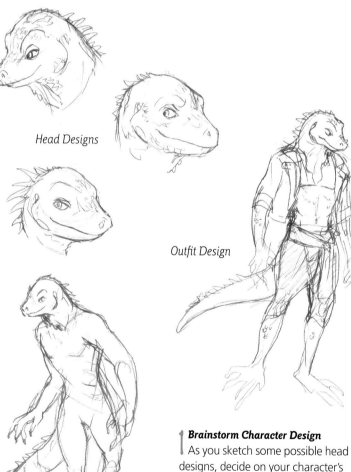

Pose and Proportions

1 Brainstorm Character Design
As you sketch some possible head designs, decide on your character's personality. Is he cute, cool, a goofball or something else? Subtle adjustments to his facial features (such as the size of the eyes, percentage of the face the muzzle occupies, detail of the scales, amount of crest spines, etc.) can largely affect his overall look. Then do some thumbnail sketches for his pose, proportions and clothing.

2 Sketch the Body Position
Using your pose thumbnail as reference, sketch a curved line of action that captures his leaning stance. Build up the iguana's torso shape along this line. Try to bring out his lizard qualities with an elongated frame. Then, sketch a circle with crosshairs for the head and connect it to the torso with a thick neck.

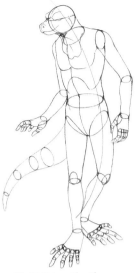

3 Build up the Shapes

Sketch the arms and legs, lean and long, following the line of action. Iguanas, like most reptiles, are plantigrade, so draw his feet flat on the ground. Each foot has five digits, with the second toe from the outside being the longest. Add a strong tail sweeping to the side. Then build up the face shape with the muzzle, brow, cheek and reptile ear. Draw the dewlap skin flap draping from the anthro iguana's lower jaw to the base of the neck.

4 Sketch the Clothing

Draw an open cropped jacket hanging loosely on his body. To create an interesting body shape, try giving him a pair of trousers, loose on top and tighter around the knees, with a low rise. Cutting the pants just below the knees emphasizes and lengthens his legs. Complete the look with a wraparound belt sash. For reference, wrap a scarf or length of fabric around your waist to study how the fabric bunches and folds.

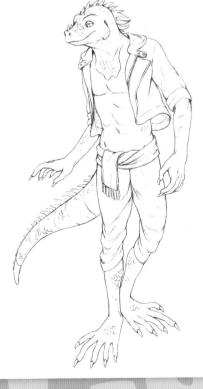

5 Define the Figure

Detail his head with an eye, scales (including a large one on his cheek) and spiny crest. Lightly sketch some small U-shaped scales in clusters running down his body, arms, legs and tail. No need to overdo it—a few here and there is enough to suggest a scaly texture. Add long claws to his fingers and toes and a row of spines down his tail. Refine your lines and erase any guidelines.

6 Finish With Color

Green iguanas are, as their name implies, usually green. Color variants of blue and brown are other options. Select colors for the outfit that match the iguana's coloration. Then, build up your shadows and highlights. Dapple a lighter color in the highlight areas to suggest a scaly texture.

Head

Let's take a closer look at the iguana's head. The spiny crest running down the center of the iguana's head, like a mohawk, fills the role of hair. Other noteworthy features include a large, round scale on his cheek called the subtympanic shield, and the tympanum, a tiny external ear membrane located about where you'd expect an ear.

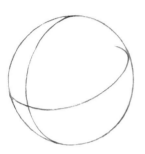

1 Sketch a Circle
Lightly sketch a circle for the head. Draw the cross-hairs to indicate a three-quarters facing.

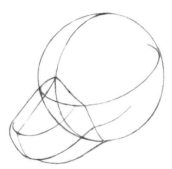

2 Draw the Muzzle
To create the upper jaw of the muzzle, start above the eye line and draw a boxy shape extruding from the head with the downward slope. Pull the mouth line past the muzzle, onto the head itself. Then draw the lower jaw.

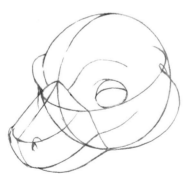

3 Build up the Face Shape
Add a pair of nostrils to the end of the muzzle. Draw the shape of the eye. For a relaxed look, give him a lowered lid. Then draw the protruding brow ridge wrapping around his circular head. Fill out the width of the face with the cheeks. Don't forget his small reptile ear where the cheek meets the eye line.

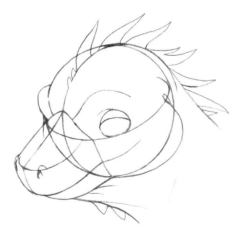

4 Add Crest and Dewlap
Extend the back of his head past the circle and continue it down to form the back of the neck. Stretch the dewlap from the lower jaw and adorn it with a row of spines. Along the centerline of the top of his head, add a crest of flexible spines.

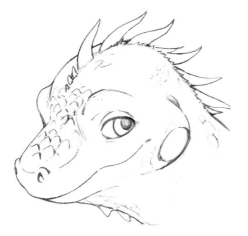
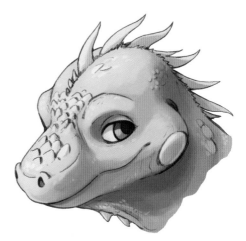

5 *Add Details*
Fill the eye shape with the iris and pupil, partially overlapped by the upper lid. Add some smaller raised scales amidst the crest and a single large scale on his cheek. Draw some interlocking scales of varying size along his muzzle, head and neck for texture. Then erase your guidelines.

6 *Finish With Color*
Use bright greens and blues to give your iguana a vivid sheen. Then build up the shadows and highlights. Dapple flecks of lighter colors across the skin to create the effect of scales reflecting an extra glint of light.

Head Coverings

Since hair is a mammal exclusive feature, it's often left off scaly characters. In its place, you can adorn the reptile head with species-appropriate head coverings like crests, frills, horns, scaly outcroppings and even feathers. Of course, since this is the realm of fantasy, there's no rule that says you can't give your scaly character human hair. If they can walk and talk like people, they can have hair, too. Hats are another option.

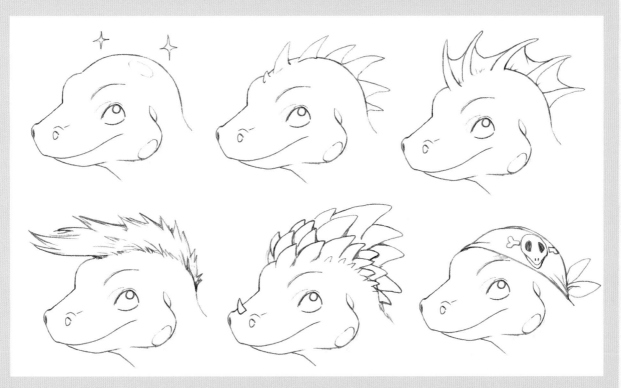

SCALIES
Snake

Dangerous and exotic, snakes have long frightened and fascinated humankind. Examples of anthropomorphic snakes reside throughout mythology and religion. In Hinduism and Buddhism, there are the naga—half snake, half human deities of extraordinary beauty. Poet John Keats described the demigoddess of Greek mythology, Lamia, as a woman with the tail of a serpent below the waist.

Based on the venomous king cobra, this particular anthro snake is a queen among kings. As such, she delights in bossing around others and getting her way. Try to express her sassy attitude in her body language.

Head Concepts

Outfit Ideas

Outfit Design

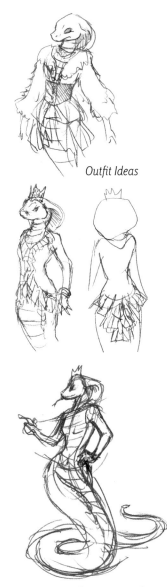

Pose and Proportions

1 Brainstorm Character Design
Do some thumbnail sketches exploring your cobra's body proportions, costume and pose. Sketch quickly; don't get caught up in the details. Focus on the overall look and shape. The idea is more important than tight, refined art at this early stage of development.

2 Sketch the Body Position
Start with a serpentine line of action. Along its path, draw her slender torso with an elegant twist: chest pointing left, hips pointing right. Note the tilt of the hips and shoulders. Then give her an elongated neck, ending in a sphere for the head.

3 Build up the Shapes

From the hips down, complete the lower half of her body in the form of a snake with a coiled tail. Unify her upper and lower body by drawing large flat belly scales extending from her neck to the tip of her tail. Next, draw her arms posed assertively, one pointing in accusation, the other pressed against a hip. Sketch a pair of lines from the back of the head to the shoulders to form the cobra's hood. Finally, draw her brow, jawline and short boxy muzzle.

4 Sketch the Clothing

Due to her snake lower half, skirts look strange, and pants are a no-go. Instead, focus your efforts on giving her a stylish top with decorative details fit for a fashionista. Accessorize her with some jewelry, perhaps a ring and some gold bracelets. Of course, she'll need a crown to symbolize her queenliness.

5 Detail the Figure

Work through your drawing, refining the line work and erasing any guidelines. Detail the head with a forked tongue poking through closed lips, and a fierce, glaring eye. Add some small, interlocking scales to the inside of her hood for texture. Build up the curvature of the body scales to give them depth. Elaborate on the details of the outfit and add a few extra folds around the waist and the hanging sleeves.

6 Finish With Color

Cobras come in shades of tan, brown and black with a cream-colored belly. I went with reddish-brown and tan. But remember, you're making an anthro snake, not a realistic one, so you needn't limit yourself to ordinary hues. How about royal purple? Select a color for the outfit that complements her scales. Add shadows and highlights to finish.

Cobra Hood

The cobra's best-known feature is its impressive hood, a flap of skin on both sides of its neck that it puffs up when threatened. Elongated ribs extending from the neck give the hood its rigid shape. Here's a simple step-by-step approach to drawing it.

Menacing Mouth

The inside of the snake's mouth is a sight to behold. In addition to a fearsome pair of fangs (venomous snakes only), the snake has several rows of smaller teeth. Also noteworthy is its forked tongue, which extends from a sheath positioned toward the front of the mouth. Behind that is the glottis, a hole that allows it to breath while it swallows prey whole.

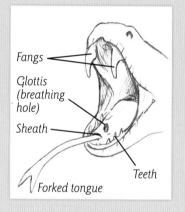

Fangs

Glottis (breathing hole)

Sheath

Teeth

Forked tongue

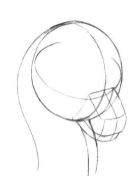

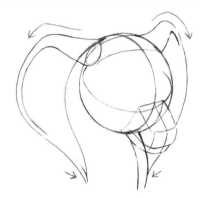

1 Sketch the Basic Shape
Start with the basic structure. Sketch a sphere with crosshairs to indicate her facing, a boxy muzzle and a long, tube-like neck.

2 Draw the Hood Shape
Hoods vary in width, from Dumbo-sized to small. Decide what works best for your cobra. Then, from the side of the head, pull a line curving out to the desired size. Connect the line to the base of the neck. Do the same on the other side, taking into account perspective. Then draw an inner line on both sides to give the hood thickness.

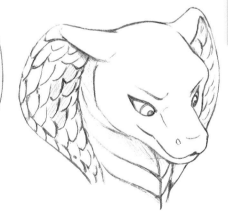

3 Build up the Shapes
Use lines to map the inner surface of the hood into neatly spaced rows. Give the inner shape a slight curvature to reflect the curved ribs holding the hood aloft.

4 Add Details
Using your guidelines, fill the inner hood with interlocking scales. You can create a bumped-out appearance by allowing them to overlap. Complete the details of the head, including the eyes, brow, cheek, nose and neck plates. If you like, use pencil shading to add texture and depth.

Snake Body

Lacking arms and legs, snakes provide a new challenge for the furry artist. The first thing you'll need to decide is how you want to go about "humanizing" the snake's form. Add a pair of arms and legs, and you risk losing the unique attributes that set the snake apart from lizards and skinks.

 The classic solution depicts the anthro snake with arms while retaining the serpentine tail from the waist down. Other approaches involve providing the snake with arms and legs, but elongating the neck and torso, and endowing it with a long tail to evoke a serpentine form. Let's look at a few examples. See which variation you like best, or mix and match to create an anthro snake all your own.

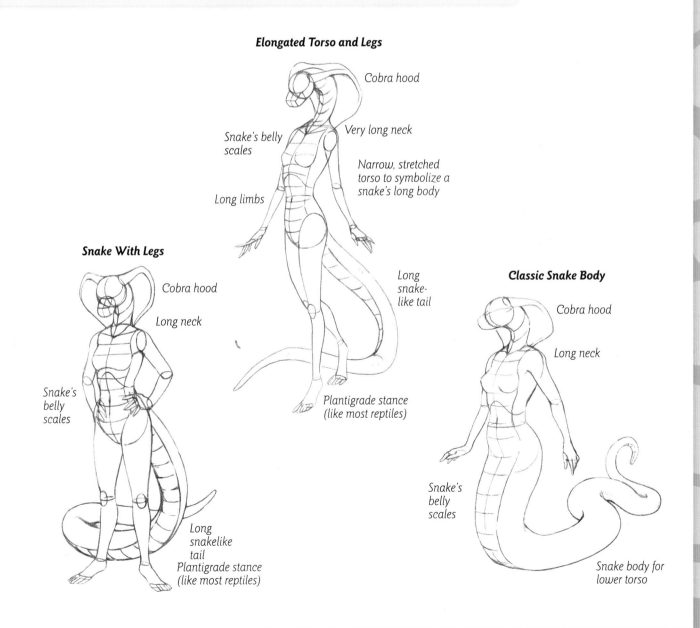

Elongated Torso and Legs

Cobra hood

Snake's belly scales

Very long neck

Narrow, stretched torso to symbolize a snake's long body

Long limbs

Long snake-like tail

Plantigrade stance (like most reptiles)

Snake With Legs

Cobra hood

Long neck

Snake's belly scales

Long snakelike tail
Plantigrade stance (like most reptiles)

Classic Snake Body

Cobra hood

Long neck

Snake's belly scales

Snake body for lower torso

Crocodile

Crocodiles, along with alligators, caimans and gharials, are members of the (appropriately named) Crocodylidae family, a dangerous collection of aquatic reptiles with armored bodies and long, toothy jaws.

Like other top-of-the-food-chain predators, crocodiles are the subject of many myths and legends. Perhaps the most famous anthropomorphic example is Sobek, the ancient Egyptian Nile god, depicted with the body of a man but the head of a crocodile.

Instead of a deity, the anthro croc we'll be drawing is a tough guy decked out in mammal leather. As if the teeth weren't enough, his muscular arms, legs and mean glare suggest you might want to keep your distance…and definitely don't make the mistake of calling his kilt a skirt.

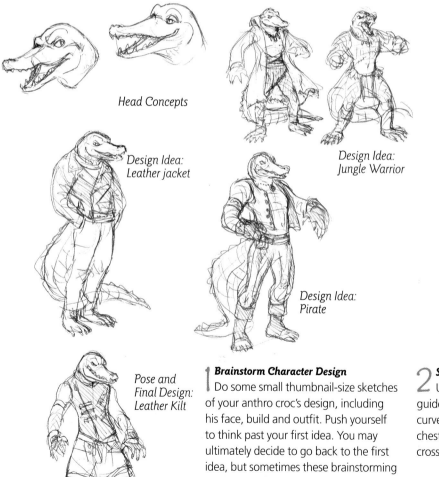

Head Concepts

Design Idea:
Leather jacket

Design Idea:
Jungle Warrior

Design Idea:
Pirate

Pose and
Final Design:
Leather Kilt

1 Brainstorm Character Design
Do some small thumbnail-size sketches of your anthro croc's design, including his face, build and outfit. Push yourself to think past your first idea. You may ultimately decide to go back to the first idea, but sometimes these brainstorming sessions can lead to something fantastic. I settled on my final sketch, but any of these designs could make for fun character pictures.

2 Sketch the Body Position
Using your thumbnail sketch as a guide, sketch a line of action with a nice curve. Then draw the torso with a broad chest and thick neck. Add a sphere with crosshairs for the head.

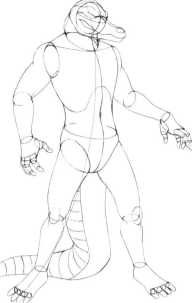

3 Build up the Shapes

Draw a pair of long jaws, and a ridged brow, to fill out the shape of the head. Attach a pair of muscular arms to the torso. Then, draw the legs with a plantigrade stance. Note that crocodiles have four toes on each foot, and five fingers on each hand. Don't forget his thick, rudder-like tail. Use surface lines to help you build up the tail shape.

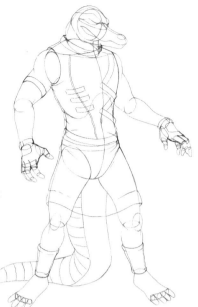

4 Sketch the Clothing

Time to give this bad boy his leather getup. Draw the top tight and formfitting, using the sleeveless design to show off his muscular arms. Lightly sketch a path for a zipper and some decorative belts. Then add his leather kilt (nontraditional, so no pleats). Tie the outfit together with a pair of leather gloves and greaves (bands around the lower leg).

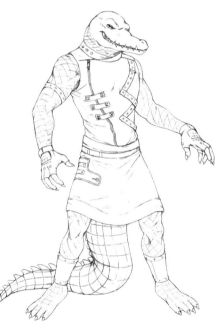

5 Detail the Figure

Carefully pencil the crocodile's scaly pattern wherever his body is visible. Decorate his menacing grin with pointy teeth. Draw his eye with a slightly lowered lid to give him a devious look. Detail the outfit with studs, belts and zippers. Add claws to his fingers and toes, plus webbing on the feet. Finally, erase your guidelines.

6 Finish With Color

Play dark against light by contrasting the pale green of his scales with his black leather clothing. Color the croc's underbelly a light cream. Use deep shadows and bright highlights to bring out the shiny qualities of the scales and leathers.

CROCODILE FEATURES
Jaws and Teeth

Let's take a closer look at the crocodile's signature toothy grin (don't worry, this one won't bite). Its powerful jaws are lined with sharp, intermeshing teeth that are visible even when its mouth is closed. Crocs have more than sixty teeth, but you only need to draw enough to make a menacing impression. The many teeth and length of the croc's snout can make it difficult to draw. The trick is to simplify the mouth into a boxy shape, and build up the details from there.

1 Sketch the Basic Shape
Sketch a sphere with crosshairs. Draw a long rectangular box extending from above the eye line to make the upper jaw. Sketch a small circular shape at the end for the nasal disc. Pull guidelines from the edges of the upper jaw to line up the lower jaw. Build up the lower jaw's shape, rounding the ends into meaty cheeks. Finally, sketch the shape of the neck and brow.

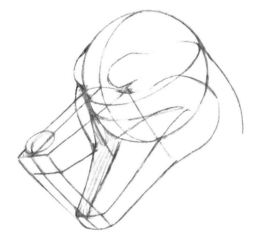

2 Add Details
Refine the shape of the upper and lower jaws with the proper curvature (see Crocodile Smile sidebar). Then line them with conical teeth (leave some space between each one). Add the rest of the details, including eyes, nostrils and tongue, then erase your guidelines.

Crocodile Smile

Note the overbite of the upper jaw. Grooves in the upper and lower jaws allow for a closer puzzle-piece fit.

The crocodile's snout tapers at the end, setting it apart from the stubbier, wider snout of its alligator cousin.

FOR MORE ON DRAWING CROCODILE JAWS AND TEETH, DOWNLOAD THE FREE INFORMATION AT IMPACT-BOOKS.COM/MORE-FURRIES

CROCODILE FEATURES
Scales

The crocodile's skin consists of thick, plate-like scales called scutes. Unlike a snake's scales, these do not overlap. Here are two varieties you'll encounter on crocodilians, and how to approach them.

Circular Scales

Placement on body:
Sides, neck, arms and legs

1 Brainstorm Character Design
Draw horizontal and vertical surface lines following the curvature of the body. If you prefer a simpler, streamlined look, you can call the scale texture complete at this stage.

2 Fill With Circular Scutes
Fill each boxy section with circular disks. Vary the sizes and avoid perfect circles for an organic look. Leave some space between them. Erase your gridlines.

Square Scales

Placement on body: Tail
Note how towards the end of the tail, it tapers to a single triangular scute per row.

1 Draw Surface Lines
Draw equally spaced lines across the surface. Give the lines on the sides a subtle curvature.

2 Add Details
Intersect the surface lines with horizontal lines to divide them into squares. Create an organic feel by scalloping the edges of each square. Draw an additional line between the squares to create space between each scale. Run a row of triangular scutes along the edge, where the top and side of the tail meet.

Frog

Although frogs are generally considered to belong to the scaly category of anthropomorphic animals, they have no scales. Instead, they have smooth, moist skin suited for their semiaquatic amphibian lifestyle.

Examples of anthropomorphic frogs abound in the literature and popular media, such as Mr. Toad from *Wind in the Willows*, the Frog Prince from the Brothers Grimm fairy tale, and Jim Henson's most famous Muppet, Kermit the Frog. Though our anthro frog hasn't attainted the same level of fame as the previous examples, let's give her the poise and confidence of a star, coyly modeling her pond attire.

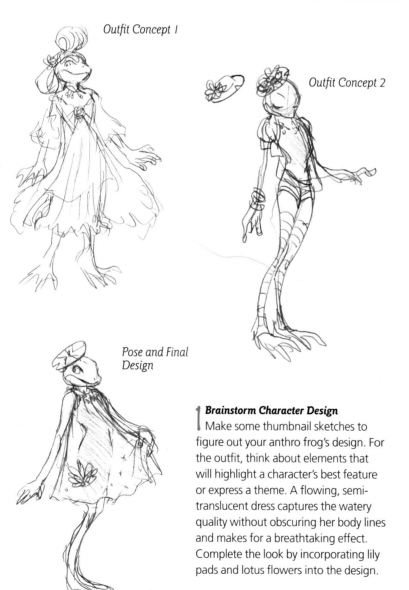

Outfit Concept 1

Outfit Concept 2

Pose and Final Design

1 Brainstorm Character Design

Make some thumbnail sketches to figure out your anthro frog's design. For the outfit, think about elements that will highlight a character's best feature or express a theme. A flowing, semi-translucent dress captures the watery quality without obscuring her body lines and makes for a breathtaking effect. Complete the look by incorporating lily pads and lotus flowers into the design.

2 Sketch the Body Position

Start with a curving line of action. Using your thumbnail sketch as reference, sketch her slender torso. Even though much of her body will be obscured by the dress, it's helpful to draw the full figure for proper placement of limbs and balance. For the head, draw a circle with the crosshairs tilting downward.

3 Build up the Shapes

Draw the arms and legs long and slender. Make one arm outstretched with a slight bend at the elbow, fingers grasping the hem of her dress. Balance the thinness of her legs with large, webbed feet. Fill out the shape of her head with round cheeks, a prominent brow and a petite, boxy snout.

4 Sketch the Clothing

Lightly sketch the contours of her flowing dress. Pull some tension lines from the collar to the point between her pinched fingers. Draw the rest of the fabric hanging loose. Then, draw a lily pad resting on top of her head like a beret.

5 Draw Surface Lines

Carefully erase the inner lines of the body covered by the dress, leaving only a subtle, broken outline. Detail the outfit with an embroidered lotus flower and sparkly beadwork. Then, beautify your charming frog-lady with large eyes and dark lashes. Don't forget to add webbing between her toes. Erase remaining guidelines. She's ready for color!

6 Finish With Color

Frogs come in a rainbow of colors, so either pick your favorite or, if you have a particular type of frog in mind, go with its color scheme. I chose a classic froggy green for her skin and blues for her outfit to continue the pond metaphor. Speckle white highlights on her skin to make it look moist and shiny. To give the dress a translucent quality, paint the areas overlapping her body a darker shade than the areas where the light shines through. Use a lighter color on the crests of the folds to bring attention to the tugging action.

Head

The frog's head is wider and flatter than the other critters covered so far. While you should try to retain as much of the shape as possible to make your character recognizable as a frog, you'll also need to make some modifications in order to anthropomorphize it. Try pulling the eyes more towards the center, and rounding out the top of the head to make space for a human-sized brain. Like everything furry though, there's more than one solution, so don't be afraid to experiment.

1 Sketch the Basic Shape
Sketch a sphere with crosshairs. Even unusual head shapes can come from a basic circle.

2 Draw the Snout
Draw a short, boxy snout extending from the horizontal eye line. Be careful to keep the horizontal and vertical edges aligned with the crosshairs. Use a ruler to double-check your angles.

3 Fill out the Shape of the Head
Widen the head by adding round cheeks on both sides. For her eyes, sketch a pair of large ovals along the horizontal eye line. Then draw the surrounding brow. Finally, sketch the lines for the neck.

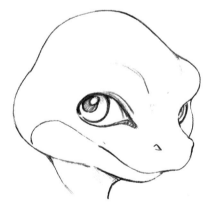

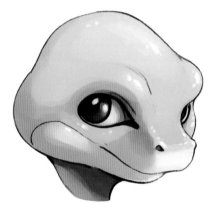

4 Add Details
Fill each eye with a pupil and highlight. Darken the lid lines to nicely frame the eyes and make them the focal point of her face. Frogs have large mouths, so pull that smile line far back on the face. Add nostrils to the snout. Erase your guidelines, leaving only the smooth contours of the head.

5 Finish With Color
Select colors for your frog head, and then apply a layer of shadows to bring out its three-dimensional shape. Dapple ample amounts of white highlights for that wet skin look, and she's done!

Webbed Feet

Frogs that spend much of their time in the water have webbed feet, an adaptation that helps them swim. The webbing itself isn't difficult to draw (just connect the thin membrane to the end of each toe), but the toes—each a particular length and number of joints—can get tricky, so let's try drawing a frog foot together.

1 Sketch the Basic Shape
Sketch a rectangle for the foot base. Arch the back of the rectangle upwards to create the ankle and heel.

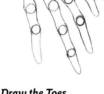

2 Draw the Toes
Divide the front section of the rectangle into five circles—one for each toe. Map the path of each toe using circle guides for joints. The inner two toes are the smallest with only one joint each. The middle and outer toe each have two joints and the second from the outside is the longest with three joints. Encapsulate the joints in spindly frog toes.

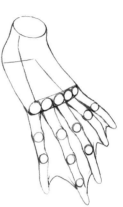

3 Draw the Webbing
Connect the inner end of each toe with a curved line to create the webbing. Add some folds to indicate the flexibility of the membrane. Darken the inner creases between the toes.

4 Add Details
Erase the guidelines, leaving a clean contour of the foot. Refine and darken your lines. For texture, add some light hatching lines to the webbing.

5 Finish With Color
Start with your base colors, then work in the shadows. Try to give the webbing a translucent quality. This is easier to achieve by having something behind the foot show through the membrane, but the effect can still be simulated by making the colors less intense. Give the frog its wet look by dappling small white highlights along the edges of toes and joints and anywhere else catching the light.

Triceratops

Triceratops is an herbivorous dinosaur best known by its three facial horns and impressive bony frill. An important detail to note: Triceratops, like most dinosaurs, walks on his toes with the digitigrade posture.

With its long horns and well-armored body, triceratops is thought to have been capable of defending itself against Tyrannosaurus rex attacks. Such a display of bravery makes our anthro triceratops an ideal candidate for knighthood.

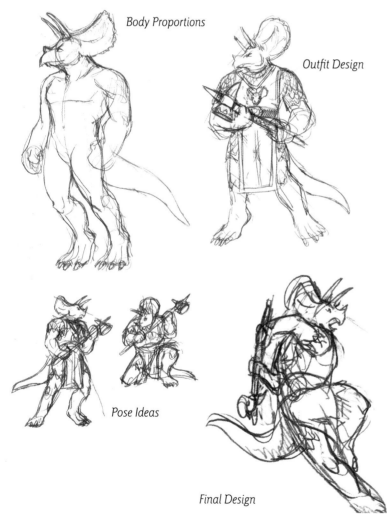

Body Proportions

Outfit Design

Pose Ideas

Final Design

1 Brainstorm Character Design
Start with a rough sketch of your anthro triceratops, sans clothes, to work out his body proportions (try for a thick and muscular build). Then think about his armor and weapon. How about giving him a skull-emblazoned tabard (a sleeveless coat that is open on the sides) layered over chain mail and a spiked hammer? Finally, brainstorm knightly poses that portray him as strong and dignified.

2 Sketch the Body Position
Start with a sharply curving line of action. This triceratops is using his whole body to swing a hammer, so you want to draw him off-balance to create a sense of motion. Give the torso shape a broad chest. Sketch a small circle for the head atop a sturdy neck, pulling in the opposite direction of the body to add tension.

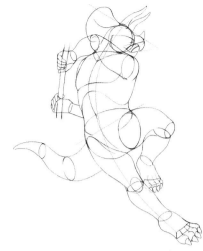

3 Build up the Shapes
Using basic shapes, sketch the rest of his face, including the beaklike muzzle, horns and bony frill. Use a ruler to help align the horns and crest with the top of his head. Next, draw his muscular arms positioned in mid-swing, bursting with energy. Sketch the handle of the hammer to ensure proper hand placement and finger spacing. Then draw the legs, one fully extended, and the other raised. You can increase the tension even more by drawing the tail pulling in the opposite direction of the head.

4 Sketch the Clothing
Refer to your character design sketch for inspiration as you draw the triceratops' knightly garment. Sketch a long, knee-length tabard tightly clinging to his chest, held in place with a belt around the waist. Decorate the tabard with a coat of arms or other imagery, like a grisly triceratops skull. Complete the basic shape of the hammer. Sketch the contours of his chain mail armor. Then divide the inner space of the mail into even rows of guidelines.

5 Add Details
The chain mail is easier to achieve than it looks; simply sketch rows of repeating Cs following your guidelines to fill the chain mail with tiny rings. Add some spikes to the hammer and his bony frill following the curvature of the shapes. Draw light, wobbly lines on the inside of the hammer's handle to give it a wood grain. Add texture and definition to his skin and horns with hatching lines placed in valleys and peaks. Finally, erase your guidelines and darken your lines.

6 Draw Surface Lines
No one knows for sure what colors the triceratops (or most other dinosaurs) might have been, so it's up to you to use your imagination and pick what you like best! I used a rusty brown with yellow accents for his skin and outfit and a steel blue for the chain mail. Build up your shadows and highlights. Then dapple some additional highlights on his skin to suggest a bumpy texture. Now take a step back to admire your fierce hammer-swinging triceratops from a safe distance!

Horns

With a name that literally means "three-horned face," what would a triceratops be without its horns? It's worth the effort to get the horns looking just right! In this section, you'll find tips to help you draw them.

1 Sketch the Basic Shape
Start simple with a long cone shape. The exact curvature of the horn varies from triceratops to triceratops (it's thought that the horn shape changed as the triceratops' aged), but in general, try for a forward-facing shape that tapers to a point.

2 Add Details
When you're happy with the shape, you can add texture details. Draw some vertical lines running up the length of the horn to indicate grooves and surface striations. Then add a few curving lines around the base to bring out the roundness of the shape.

No Time Travel Required

For further inspiration, nothing beats seeing your animal subject up close. Since dinosaurs went extinct millions of years ago, you won't be able to see a living triceratops without a time machine, but you can still take a trip to a natural history museum to study their fossils!

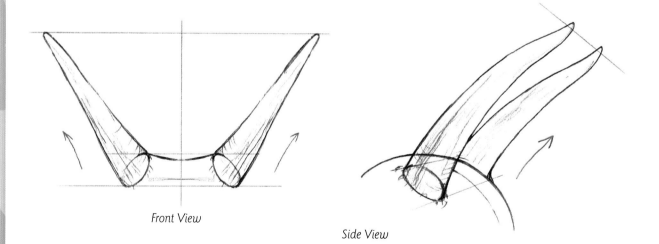

Front View

Side View

Placement and Direction
Position the triceratops's horns right above the eyes. They should point forward with a slight curvature, while splaying outward to either side of the head. Watch your symmetry when drawing a straight-on view. While each horn needn't be identical, definitely try to get the same angle.

TRICERATOPS FEATURES
Neck Frill

It's unknown whether the triceratops used its bony neck frill as a shield to protect its neck and shoulders or as a decoration for dominance and courtship or some other reason. Regardless, it's an impressive structure.

1 Sketch the Basic Shape
Start by drawing a sphere for the triceratops' head. Use crosshairs to indicate facing. At the top of the head, place a pair of horns, using horizontal guidelines to align the tops and bottoms. Sketch a roughly circular shape behind the head for the neck frill. Find the midpoint along the top, and draw a curving line from this point to the back top of the head.

2 Refine the Shape
Draw two additional curving lines on either side of your first one. These lines represent the frill's ridges. Reshape the side of the frill to create the cheekbone and ear opening. Then, add small triangular bones along the edges of the structure. Try to draw them with a discernible depth. Extend the edges of the frill so it surrounds the base of each tiny bone.

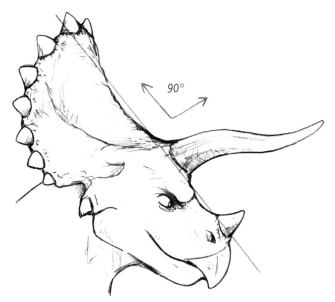

3 Add Details
Erase your guidelines. Then, use a mix of sketchy and hatched lines to express the grooves and ridges in the triceratops' frill and horns. Don't be afraid to get a little bit messy—an unruly line here or there can add texture.

Putting It All Together
Notice how the frill and horn bases align along a single diagonal line. In addition, the head horns emerge from the head at approximately a 90° angle. Keep these in mind to help with the placement of features.

Raptor

The basis for this anthro is deinonychus, a type of dromaeosaur, better known as raptors, vicious predators popularized in the 1993 film *Jurassic Park*. Since then, there's been evidence indicating that they were covered in feathers instead of scales.

Deinonychus walked digitigrade on two legs, each equipped with a sickle-shaped killing claw. Our anthro raptor is more of a fun-loving party animal than a killing machine, but even so, be sure to highlight her deadly talons and sharp teeth in your drawing.

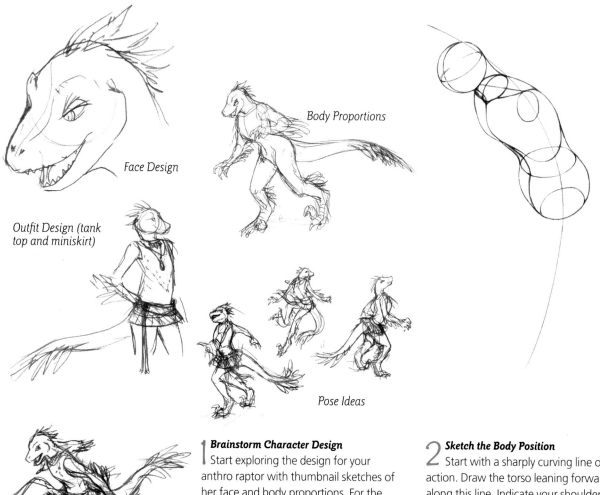

Face Design

Body Proportions

Outfit Design (tank top and miniskirt)

Pose Ideas

Final Design

1 Brainstorm Character Design
Start exploring the design for your anthro raptor with thumbnail sketches of her face and body proportions. For the outfit, consider designs that won't get in the way of the feathers, like a sleeveless shirt. Then sketch some lively, energetic poses. Pull all your favorite ideas together in a final sketch you can use as reference for your full-size drawing.

2 Sketch the Body Position
Start with a sharply curving line of action. Draw the torso leaning forward along this line. Indicate your shoulder and leg attachment points. Then sketch a neck and add a sphere with crosshairs for the head.

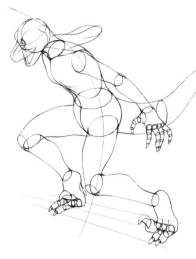

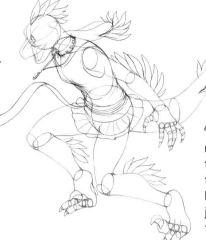

4 Sketch the Clothing

Sketch the clothing, keeping details minimal and focusing on shape. Draw the pleats of the skirt lifting with her turning motion. Sketch the path of the belt as a flat, papery shape. Add some jewelry indicating motion through the flittering necklace chain.

Then, pencil the basic contours of the large feathers on her head, arms, tail and legs. Evidence suggests that the deinonychus' arms were completely lined with feathers, like wings, but you may wish to use them as accents.

3 Build up the Shapes

Extend the shape of the head with the muzzle, cheek and brow lines. Draw her arms sweeping outwards. Add her long, tapering tail held out straight with a slight curvature to suggest motion. Draw the legs bent at the knees, like she's about to spring into action. Use guidelines to line up the feet in perspective. Finally, add sharp claws at the ends of her fingers and toes, including one large, sickle-shaped claw on each foot.

5 Add Details

Draw the nostrils, eye, ear opening and pointy teeth to complete the face. Using jagged lines, layer some light plumage along her tail and legs. Sketch some breakages to the feathers on her head, arms, legs and tail to give them a rougher texture.

Add some creases to the clothing, especially around the bend at the waist and between skirt pleats. Divide the belt into four twisting tassels. Cover her feet with scaly plates. Erase your guidelines.

6 Finish With Color

Deinonychus' true colors are unknown so use your imagination and go wild. I chose a warm palette of reds and oranges for her plumage, a neutral white and black for the top and skirt and, for extra flair, neon green on the belt.

Build up your shadows to add depth. Apply highlights on her body using small dabs to create a feathery texture. Finally, add some strong highlights to those deadly claws to make them look hard and shiny.

Tail

Deinonychus has a long, stiffened tail covered in feathers that it uses for balance. Don't let the feather details overwhelm you! The key to drawing the tail is to build up the basic structure first and save the plumage for last.

Tail positions are limited. The tail is capable of side-to-side and up and down motions only around the base; the end half of the tail is rigid due to locking bony rods in the vertebrae.

1 Draw the Tail Shape
Sketch the basic shape of the tail, tapering to a point.

2 Sketch Guidelines
Sketch some surface lines to establish the curvature of the shape. Then, draw a line running down the length of the tail to divide it into a large top and smaller bottom portion.

3 Add Feathers
Fill the top side of the tail with light plumage, using quick pencil marks in a jagged fashion. Don't just randomly draw lines anywhere though; make sure they flow down the length, curving with the surface lines you placed in the previous step. Then, from the dividing line, draw the longer tail feathers. Allow them to overlap slightly as they extend towards the tail tip.

4 Refine Details
Continue filling in the plumage until you're satisfied. For more texture, add some breaks in the feathers and some rough curving lines along the bottom portion. Erase any undesired stray lines.

5 Finish With Color
Fill the tail with the colors you've selected for your anthro raptor's plumage. Use multiple bright-colored strokes dashed in the same direction along the feathers to create the appearance of feather vanes. Finally, build up the shadows and highlights to make those feathers really shine!

RAPTOR FEATURES
Feet

Deinonychus' standout feature is the large, curved claw on the second toe of each foot, for which it was named (deinonychus means "terrible claw"). This toe arches upward, while the two smaller toes lay flat for stability. Although not visible from this angle, there's a fourth toe on the inner side of the foot, which doesn't make contact with the ground. Like bird's feet, scaly plates, called scutes, cover deinonychus' feet from ankle to toe.

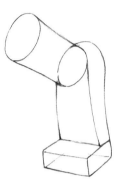

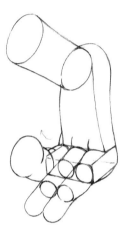

1 Sketch the Basic Shape
Sketch the shape of the foot in three segments. Draw the heel raised high in a digitigrade stance.

2 Block in the Toes
Sketch the two outer toes of equal size pressing into the ground to support the raptor's weight. Draw the much larger toe curving upward, off the ground.

3 Add Claws
Draw claws extending from the ends of the toes. Give the largest toe an impressively sized sickle-shaped claw. Add a line down the middle of the claw to divide the surface into top and side areas (useful for shading and visualizing the overall shape).

4 Detail With Scales
Carefully pencil the scutes on your raptor's foot, following the shape contours. Leave a little space between each segment. Add some light shading and sketchy lines for a rougher textured look. Erase your guidelines to finish that foot!

CHAPTER 4
Mythical Creatures

From awe-inspiring dragons to the elusive Jackalope, mythical creatures spellbind us with their otherworldly looks and supernatural powers. Some are a combination of creatures, like the majestic griffin (half-eagle, half-lion), the gentle kirin (a blend of deer, ox and carp) and the curious Xuanwu (a snake-turtle). Others spring from individual animals, but twist their inspiration in a fantastical way, like the foxy nine-tailed kitsune.

Considering that the formula for furries already involves combining humans and animals, why not throw even more ingredients into the mix? This chapter is all about moving beyond the norms and letting your creative fantasies take flight. You don't need magic to conjure mythical anthros. With this chapter as your guide, pencils, paints and imagination are all you need to create the stuff of legends!

"My process varies a bit from day to day, but overall I try to keep everything as simple as possible. For a large illustration like this, I start with lot of smaller doodles with ink and markers to get in the spirit of things and to better envision the world around the character. Next, I make a sketch in Photoshop® and move onto a quick underpainting. Once I'm satisfied with the composition and color scheme, I'll work on refining and detail from back to front. I don't worry too much about layers. I like to merge them as I go. One thing I've learned—if you know there's a part of your painting that's going to be more difficult, always (always) do it first. It'll save you a lot of frustration and rage-quits later on." —Kristen

Quiescent
by Kristen Plescow

Griffin

The griffin (also sometimes spelled griffon or gryphon) is a majestic mythical beast, traditionally portrayed with the lower torso of a lion and the head, talons and wings of the eagle. Regarded as a fierce, but noble protector of precious treasures, the griffin appears in art as a popular symbol throughout Western civilization. While there are variations on how to represent a griffin, we'll create our anthropomorphic version based on the classic depiction.

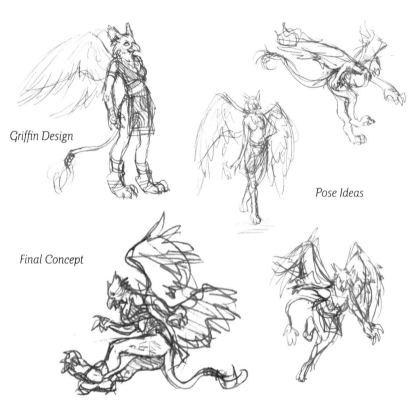

Griffin Design

Pose Ideas

Final Concept

1 Brainstorm Character Design
Sketch ideas for your griffin, exploring ways to combine the upper body of an eagle with a lion's legs and tail into an appealing anthro design. For the clothing, consider a design that allows freedom of motion, particularly for her wings. Then, create thumbnails for energetic poses that showcase the strength and ferocity of her dual-predator nature.

2 Sketch the Body Position
Working from your thumbnail concept, sketch a forward-curving line of action. Keep in mind this is a low angle shot, so sketch the body as though you are looking at it from below. Increase the size of the lower torso, as though it's closer to your eyes. Inversely, you'll want to make the head smaller to indicate it's farther away from the viewer. Use guidelines to align the hips and shoulders.

Birds of a Feather

If you're feeling adventurous, you can try substituting the lion with a different type of feline, and/or the eagle with another type of bird to create a whole flock of unique griffins! How about a hummingbird-housecat or an owl-tiger griffin?

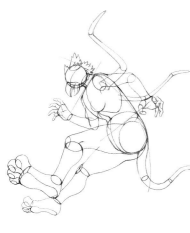

3 Build up the Shapes

Fill out the shape of the head with a beak, fluffy feathers and a pair of elongated feathery ears. Next, sketch the arms with grasping hands like a bird's talons. Extending from her shoulder blades, draw the basic bone structure of the wings. Draw the legs kicking out like an eagle in a hunting swoop, but with a lion's padded feet. Exaggerate the size of the leg closest to us. Finally, sketch the lion tail trailing behind her.

4 Sketch the Wings and Clothing

Sketch the basic shape of the wings in three parts consisting of the primary, secondary and scapular feathers. Layer on the smaller covert feathers above those. Next, draw her snug, wraparound top. Along the side seam, where the top fastens together, dash several lines to indicate the fabric tugging against the tight fastening. In contrast, sketch the skirt loose to highlight her leaping motion. Accessorize her outfit with a tail band and open-toe footwear.

5 Define the Figure

Give your griffin a fierce look with a glaring eye, lowered brow and long claws on the tips of her fingers and toes. Add large heart-shaped pads to the bottom of her feet. Fluff out her cheek and neck with soft downy feathers. Detail the wings with individual feathers, paying careful attention to overlap and size. Finally, refine her clothing with additional details, shading and folds. Then erase your guidelines.

6 Finish With Color

Select colors for your griffin. For the eagle half, use white for the head plumage, dark brown for the wings, yellow for the taloned hands and for the lion half, tawny brown for the fur. I rendered the outfit with a light blue to remind the viewer of the sky, and complement the earthy tones of her fur and feathers. Add shadows and highlights with an overhead light source in mind. Use deep shadows on the underside of her wings, legs and chin. Make those metallic bands shine with bright highlights.

Feathered Wings

Wings have the power to bestow their subject with both the gift of flight and an awe-inspiring silhouette. Wings are also undoubtedly one of the more complex animal features an artist can tackle, but it becomes easier once you understand some basics of wing anatomy. This section sets out to demystify the feathery structure with a systematic approach to help you draw wings with confidence.

Note that wing shapes and specifics vary by bird species. For this demonstration, we'll be drawing the sweeping eagle wings of a griffin.

1 Sketch the Bone Structure
Start by sketching the bones of an open eagle wing as seen from the front/underside. Note that while similar to our arm bones, their humerus is shorter and the ulna and radius are longer. Since the wing is ultimately coated with feathers, you won't always need to depict the understructure in exacting detail. For a quicker buildup, once you feel you have a clear concept of wing anatomy, you can substitute basic tube shapes, or simple line segments, for the upper arm, forearm and hand bones.

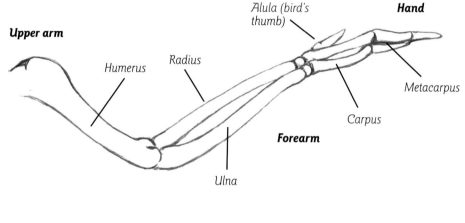

Upper arm

Humerus

Radius

Alula (bird's thumb)

Hand

Metacarpus

Carpus

Forearm

Ulna

A Bird's…Arms?

Feathers covering the wing make it difficult to visualize the underlying structure. However, if you were to peek below the surface, you would find a skeletal structure not too different from a human arm! Note how the wrist, elbow and shoulder correspond with joints on the wing. Thinking about it in these terms will enable you to more easily position and draw wings.

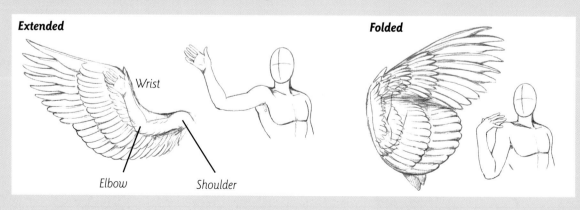

Extended

Folded

Wrist

Elbow

Shoulder

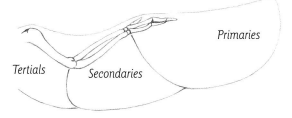

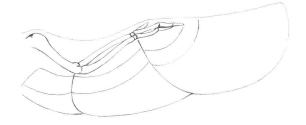

2 Outline the Wing Sweeps

Sketch the shape of the wing, divided into three sections. The farthest section, spanning the hand, comprises the bird's primary flight feathers. The middle section, spanning the forearm, comprises the secondary flight feathers. The third section, spanning the upper arm, comprises the tertial feathers. Represent the tendon that connects the shoulder to the wrist by drawing an arching line along the top of the wing.

3 Subdivide the Wing Sections

Sketch a pair of arching lines in each wing section to block in the smaller covert feathers areas.

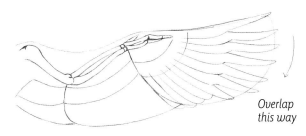

Overlap this way

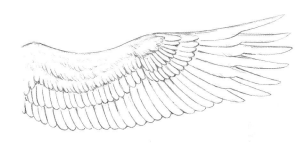

4 Draw the Primaries

Draw each of the long, primary flight feathers (the bird's "fingers") with a notched shape. Start from the end and work inward, making sure each feather overlaps the next. Notice how the feathers spread open like a fan. There are between nine to twelve primaries total, depending on the species of bird. This one has eleven.

5 Draw the Remaining Feathers

Continuing the layering pattern, draw the secondaries. These feathers are broader and shorter than the primaries, closer together and with no notch. Then, draw the tertials. Overlap the primaries, secondaries and tertials with several rows of shorter, covert feathers. Erase your guidelines and refine your lines to complete the drawing.

Take it From the Top

The topside/back of the wing is similar to the inside with two key differences. The overlap is reversed, and the alula (a bird's thumb-like feathers) are visible.

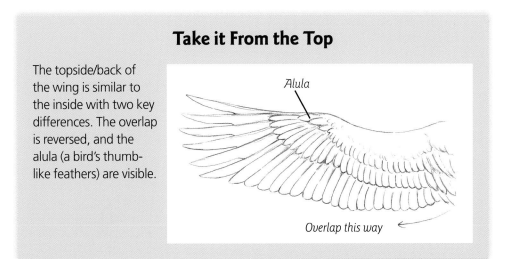

Alula

Overlap this way

MYTHICAL CREATURES
Dragon

Dragons dwell in numerous myths and legends around the world. Though generally serpentine or reptilian in appearance, specific dragon features vary widely depending their cultural origin and artist preference. Western dragons often have leathery bat-like wings, the ability to breathe fire and a penchant for treasure hoarding. Meanwhile, Eastern dragons are comparatively long, slender and sinuous, with benevolent demeanors and the capacity for flight without wings. Horns and scales are typical for dragons of both regions and feathers and fur aren't too uncommon.

Our feisty, battle-hardened anthro dragon is inspired by the classic Western dragon, but he prefers a sharp spear for combat over his breath-weapon and would rather polish his armor than a collection of gold coins.

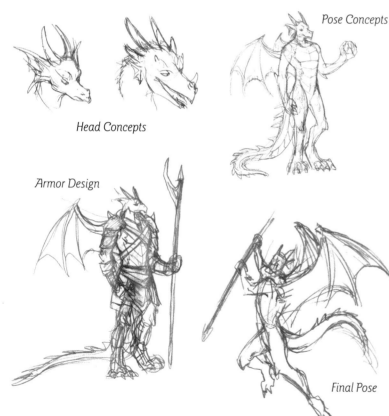

Head Concepts

Pose Concepts

Armor Design

Final Pose

1 Brainstorm Character Design
Make thumbnail sketches of your anthro dragon's design and pose. Try to inject some Western dragon arrogance into his expression. Experiment with different snout sizes and horn configurations. Give him the lean and muscular body of a warrior and lightly armor him as to not impede his motion or flight. For an impressive attack pose, think about ways to combine flight with use of his long spear.

2 Sketch the Body Position
Start with a strongly curving line of action. Sketch a squarish upper torso as seen from the back and attach it to a side view of the hips to give him a twisting pose. Draw the head using a small sphere to emphasize his large frame.

Sketch the Armor and Wings
4 Draw the solid forms of his thigh, arm and leg armor. Give them a sense of thickness and space by not drawing them flush with the body. Consider how the metal plates attach to each other and the body, and draw the appropriate straps. Complete the top and bottom of the spear (I freehanded it to give it a lively curvature; you may prefer to use a ruler). Finish the wing shape by joining the wing bones with a leathery membrane. Add some fold lines where the wing pulls taut.

Build up the Shapes
3 Draw the arms with a muscular physique, pulling up in anticipation of thrusting downward with his spear. Properly align his hands by sketching them onto a segment of the spear handle. Complete the shape of his head by drawing his brow, snout, cheeks, ears and horns. Draw the bony segments of his wings extending from his shoulder blades. Draw his tail whipping behind him, using surface lines to feel out the shape. Finally, draw the legs following the curvature of the line of action.

Detail the Figure
5 Sketch a pair of glaring eyes, looking over his shoulder. Then, draw a crest along the length of his tail. Lightly sketch clusters of half circles on his body to suggest a scaly texture. Show evidence of his numerous hard-won battles by adding tears and holes in his wings and use hatching lines to dent and score his armor. Tighten your line work and erase any guidelines.

Finish With Color
6 Select a color palette for your anthro dragon. Being creatures of fantasy, there are no correct colors. However, you can use color to hint at a dragon's powers. For example, red suggests fire-breathing capabilities, while blue or white might indicate ice-breathing. After blocking in your base colors, determine your light source and build up your shadows and highlights. Add strong white highlights to make that armor shine!

Leather Wings

The bony membranous wings of the humble bat family serve as the basis for the dragon's powerful and impressive implements of flight. However, as creatures of magic, the size of a dragon's wing is largely irrelevant to their airborne abilities and more a matter of your personal preference. A tiny wing can be a cute accent, while a wing larger than their entire body can be an impressive sight indeed. Always consider what best suits the character.

We're Not so Different

Like a bird wing, the underlying bone structure of a bat wing is quite similar to a human arm. Note the five fingers (including a thumb), arm bones and shoulder.

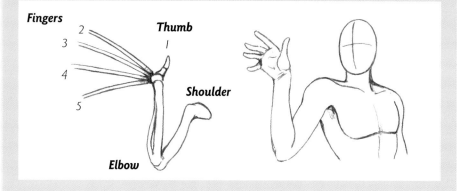

Note that fingers 2 and 3 are close together, almost like a single unit, in bat wings. You may wish to combine them together, or space them farther apart for your dragon.

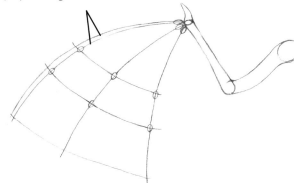

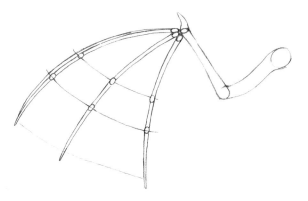

1 Sketch the Basic Structure
Draw the wing arm using basic tube shapes. Cap the end with a pointy thumb. From the wrist, extend four branching lines to plan a path for the long finger bones.

Add circles to each of the fingers to indicate prominent knuckle joints (use curved guidelines to help you align the joints).

2 Shape the Fingers
Flesh out the shape of the fingers between each knuckle bump. Then erase the underlying path guidelines.

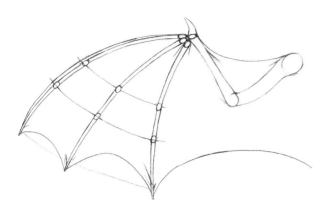

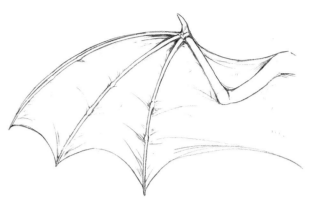

3 *Draw the Wing Membrane*
Draw a curved arch connecting each fingertip. Add another arch from the wrist to the shoulder. Anchor the wing by drawing a long arch from finger 5 to the dragon's back. Sketch some fold lines at points of tension in the membrane, like around the fingertips.

4 *Add Details*
Erase your guidelines and refine your lines. Sketch additional horizontal folds along the membrane to increase the sense of the wing stretching open. Add some light shading and hatch lines for texture.

5 *Finish With Color*
Pick and apply the base colors. Typically, the inner wing membrane has a different color than the arm portion. I used a dark red for the arm and orange for the membrane, mixed with pinks and purples to give it a translucent appearance. Add shadows and highlights to bring out the folds of the wing.

Getting Attached

For winged anthros with a primary set of arms, wings generally attach to the shoulder blades. (For anthros in which the wings are their arms, the wings would extend directly from the shoulder joints.) The membrane can either anchor to their torso, as shown here, or curve up to connect with the wing bone itself.

Kirin

The kirin is a mythical creature of Eastern origin, sometimes referred to as the Japanese unicorn due to the single horn growing from its forehead. It has the body of a deer, cloven hooves, the tail of an ox and the scales of a fish or dragon. Wise and powerful, the kirin moves through nature as a benevolent force, treading so softly on land as to not to harm a single blade of grass and walking on water without creating the slightest ripple of disturbance.

Like the rest of her kind, this gentle anthro kirin loves nature and solitude. Living deep within an enchanted wood, she watches over its inhabitants, but few have ever seen her. The length of her hair and horn mark her many years.

Head Concept

Antler Design

Outfit Design

Pose

1 Brainstorm Character Design
Sketch ideas for your kirin's design. Give considerable attention to the face and eyes—capturing the look of calm serenity is the key to her character. Also, consider the shape and branching path of her single antler. Keep the outfit simple and modest to place the focus on her long, flowing hair. Then make some thumbnail sketches of her pose, a graceful walk through her forest.

2 Sketch the Body Position
Start with gently sweeping line of action. Draw a sphere for the head, using crosshairs to indicate a downward tilt. Then, sketch her torso, slight and narrow.

3 Build up the Shapes

Draw the kirin's legs and hoofed feet in a walking stance. Center the right foot beneath her torso to provide balance for the body in motion. Give her ox tail a strong base and curve it following the line of action. Next, draw her dainty arms and hands. Sketch the stem of the flower to help position her fingers. Finally, fill out the shape of her face with a slender muzzle, cheeks, alert deer ears and an impressive antler branching from her forehead.

4 Sketch the Outfit and Hair

Draw a simple gown, draping off one shoulder and belted at the waist. Keep the folds minimal. Then, starting from the head, plan the path of her long, flowing hair. For best results, approach the hair in sections, focusing on volume, not individual strands. Give the hair a floaty, weightless quality to hint at her magical powers. Add a flower in her hand.

5 Detail the Figure

Develop the hair with additional lines and hatches, following the flow within each section. Refine the antler shape with bumps and grooves. Add a pair of soft eyebrows and closed eyes with heavy lashes. Sketch some interlocking U-shaped scales along her legs. Then erase your guidelines.

6 Finish With Color

Select colors for your kirin. Some legends describe the kirin as having an impressive five-color pelt of red, yellow, blue, white and black. In other stories, the kirin has green scales and a yellow underbelly. I chose white, blue and gold to create a tranquil and magical mood. Apply shadows and highlights with a soft diffuse approach. Evoke a glowy and majestic feel with minimal contrast between colors.

Jackalope

A whimsical chimera-type critter of North American folklore, the jackalope combines the body of the jackrabbit with antelope horns (or deer antlers). Shy and elusive, it uses its quick rabbit reflexes to stay out of sight, and is the subject of many silly claims, such as the medicinal powers of jackalope milk.

Used to his buddies making up ridiculous stories about him, Jack here is a laid-back fellow, so let's draw him in a relaxed pose. The step-by-step process of drawing a character reclining or seated is similar to drawing a character standing. The biggest difference is that with most of the body touching the ground, balance is less of an issue.

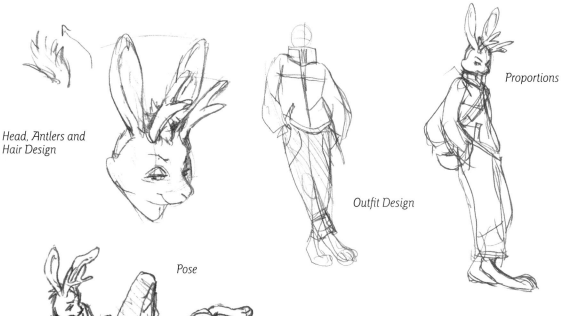

Head, Antlers and Hair Design

Outfit Design

Proportions

Pose

1 Brainstorm Character Design
Sketch design ideas for your anthro jackalope. Decide whether you prefer to give the jackalope its namesake antelope horns, or the more commonly used deer antlers (seen here). Give him a tracksuit and accessories like a sling shoulder bag, perfect attire for his on-the-go lifestyle. Then make some thumbnails of relaxed poses and pick your favorite.

2 Sketch the Body Position
Start with a horizontal line of action to depict the reclining pose. Draw the jackalope's torso curving along this path. To lift himself up on his elbows, he's flexing his abdominal muscles, so crunch the left side of his waist while stretching the right. Then sketch the head and neck overlapping the shoulder area.

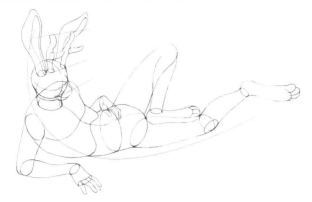
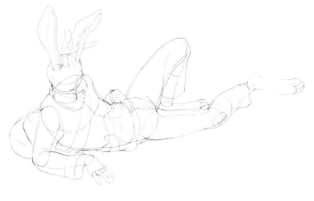

3 Build up the Shapes

Fill out the shape of his face with rounded cheeks and muzzle. Draw his long ears narrow at the base. Position the antlers in front of the ears and use guidelines to align them. Sketch the arms with the weight resting on the elbows. Then draw the legs ending in large, plantigrade bunny feet.

4 Sketch the Outfit

Draw the pants and long-sleeved jacket loosely around the contours of his body. Sketch the leg and arm cuffs hanging down with the force of gravity. Then draw the bag slung around his chest. Add tension by giving the bag strap a strong pull line in the back.

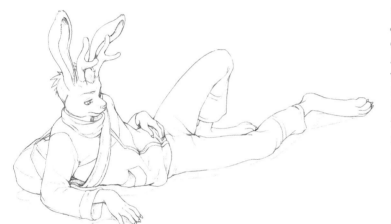

5 Detail the Figure

Give Jack a pensive expression by drawing the eyes with lowered lids, pursed lips and a neutral brow. Add a nose to the end of his muzzle. Fluff up his head with ear fur, antler fuzz and a fauxhawk hairstyle. Draw a few pronounced folds around the bends in the body, such as his waist and arm and leg nooks. Draw the inner details of the clothing, like the stitching and zipper curving and dipping with the folds. Erase your guidelines and add some pencil shading in the shadow areas to bring out the depth.

6 Finish With Color

Jackrabbits are typically earthy colors like brown and tan, but since this Jack is an antlered-rabbit of legend, you can use unusual colors, like blue or orange, to play up the fantasy angle. Balance bold accent colors with large areas of neutral tones. I used neutral tans on the pants and fur and green, orange and yellow for the jacket. Next, determine the location of your light source and add shadows and highlights. For a nice finishing touch, ground him with a drop shadow.

KIRIN AND JACKALOPE FEATURES
Cloven Hooves

A cloven hoof is like a typical horse hoof, but split into two sections. Animals with cloven hooves are known as "two-toed" ungulates and include deer, goats, pigs, giraffes and fantasy creatures, like the kirin. The hoof itself is a thick protective layer of keratin, like our fingernails, that surrounds and protects the animal's toes.

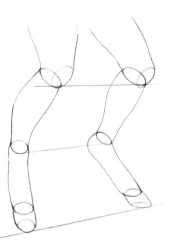

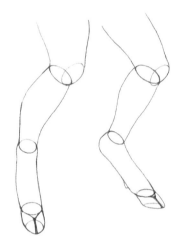

1 *Sketch the Leg Shape*
Using basic tube shapes, sketch the legs in an unguligrade stance with the weight placed on the hooves. Cap the end of each foot with a conical-shaped hoof but don't worry about the split toe yet. Use guidelines to align the leg segments.

2 *Split the Hooves and Add Dewclaws*
Cleave a line down the center of each hoof to transform it into a cloven hoof. Next, add a pair of nub-shaped dewclaws to the back of the foot (only visible from side and back views).

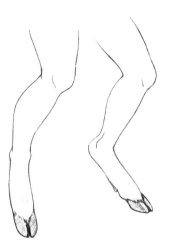

3 *Add Details*
Add indentation lines for the kneecap and ankle bones. Indicate a light covering of fur on the legs with some hatch lines. Then erase your guidelines. Use pencil shading to give the hooves a hard, shiny surface quality.

Little Dew Drops

On the back of the foot, you can see a pair of small, rudimentary hoofs called the dewclaws. With few exceptions (such as the giraffe), most cloven-hoofed animals have them.

Dewclaw

Hoof

Antlers

Antlers are bony outgrowths on the heads of most deer species (typically the males, but sometimes females), as well as fanciful creatures with deer features, like the kirin and jackalope. The shape of the antlers vary from round, pointy, flat and broad with simple to complex branching depending on the species of deer and its age.

1 Determine Placement
Sketch a sphere with crosshairs for the head. Then, lightly sketch a pair of circles, equally spaced on the forehead, to set the origin point for the antlers. For single-antlered creatures, like the kirin, place the circle on the center of the forehead.

2 Map the Antler's Path
Plan the design of the antlers as a simple lined path. Antler designs can range from simple to elaborate, multi-branching arrangements. While your antlers need not be perfectly symmetrical, strive for balance in the design.

3 Draw the Antlers
Following the path you devised, fill out the shape of the antlers. Then erase the underlying path. Use surface lines and overlapping branches to give it a three-dimensional feel. Double-check your work with guidelines to ensure that the corresponding tips of each antler align.

4 Add Details and Color
Partially erase the surface lines to allow for a clear flow through the interior of the form, while leaving some overlap. Use pencil shading, hatch lines and color striations to give the antlers a bony texture.

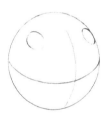

Seeing Double

While a single antler may not present too much difficulty with its tube-like form, antlers typically come in pairs, making symmetry the real challenge. For extra help, try mimicking your desired antler shape with your hands and pose in the mirror to observe how your finger branches symmetrically bend and curve.

Kitsune

The mischievous kitsune is a multi-tailed mythical fox from Eastern folklore that possesses great wisdom and magical powers, such as shape-shifting. As they age, they gain additional tails and supernatural abilities. When they grow their ninth tail, their fur turns a golden sheen and they become kyuubi no kitsune (literally, nine-tailed fox).

Ever the trickster, this anthro kitsune presents a challenge to artists: to draw her nine twisting tails without succumbing to confusion. Avoid mistakes by drawing them systematically, one at a time. You'll overcome her nightmarish test and possess a beautiful kitsune drawing at the end, too.

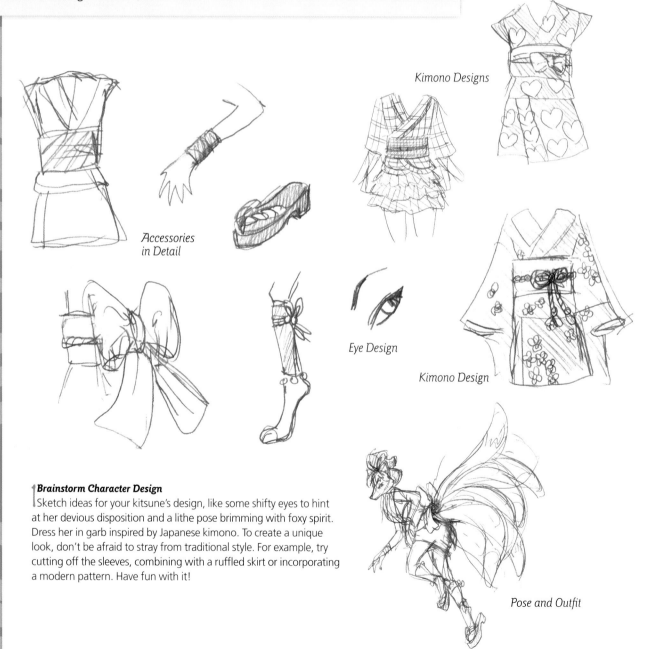

Kimono Designs

Accessories in Detail

Eye Design

Kimono Design

1 Brainstorm Character Design
Sketch ideas for your kitsune's design, like some shifty eyes to hint at her devious disposition and a lithe pose brimming with foxy spirit. Dress her in garb inspired by Japanese kimono. To create a unique look, don't be afraid to stray from traditional style. For example, try cutting off the sleeves, combining with a ruffled skirt or incorporating a modern pattern. Have fun with it!

Pose and Outfit

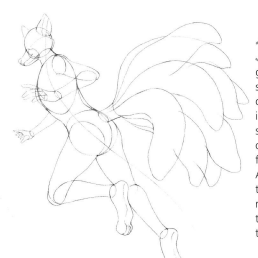

2 Sketch the Body Position

Sketch a S-curved line of action. Draw the torso tilting forward, rib cage from a side view, like the thumbnail pose. Sketch a sphere for the head with an eye line indicating a downward tilt.

3 Build up the Shapes

Fill out the head shape with large triangular ears, fluffy cheeks and a pointy fox snout. Draw the arms, with the left coming out toward us, and the right diminishing into the distance. Then draw the legs in a springy run, following the tilt of the line of action. Sketch each tail shape starting from the base of the spine and puffing out. Arrange them in a balanced fashion with the top tails overlapping the lower tails. To reduce confusion, you may wish to number the tails and erase overlapped portions of the tails as you work.

4 Sketch the Outfit

Pencil the sleeveless kimono over the shape of her body with minimal folds or curves. Wrap an obi belt around her waist, then layer on accessories like wristbands, geta sandals, ties and bells. Finish the look with a cute ribbon around the base of her tails.

5 Detail the Figure

Detail the kitsune's face with a smirk and a sly gaze. Give her a sculpted hairstyle; shade the underside to show volume. Suggest a furry body texture by drawing small jagged edges in select places, such as her elbows, cheeks, inner ear, heel, shoulders and especially her numerous tails. Refine the outfit details, adding braiding on the belt, and subtle folds in the fabric. Don't forget claws on her fingers and toes. Erase your guidelines.

6 Finish With Color

The fur color of a nine-tailed kitsune is white or golden, while kitsune with fewer tails are typically fox-colored (red, gray, black, white, etc.). Once you've settled on the fur color, select complementary colors for her outfit. Add shadows and highlights. Use jagged strokes to bring out the fur texture. Finally, paint a design on the kimono. Pay attention to the play of light, shadow and shape to integrate the details into the outfit.

MYTHICAL CREATURES
Xuanwu

The Black Tortoise of the North, Xuanwu (also known as Genbu), is one of the four guardian beasts based on constellations in Chinese astrology. Xuanwu represents the north, the element of water and the winter season. The celestial guardian is depicted as a combination of a turtle and snake, usually in the form of a tortoise with a snake's tail, a tortoise with a complete snake for a tail, a snake coiled around a tortoise or a tortoise body with a snake's head and tail.

It's said that two heads are better than one, so why not give the snake a prominent role in your anthro version of Xuanwu? Though they can be challenging, multi-character pictures present opportunities for fresh poses through character interaction. Take eye contact into consideration and if there's physical contact, make sure it's spatially possible.

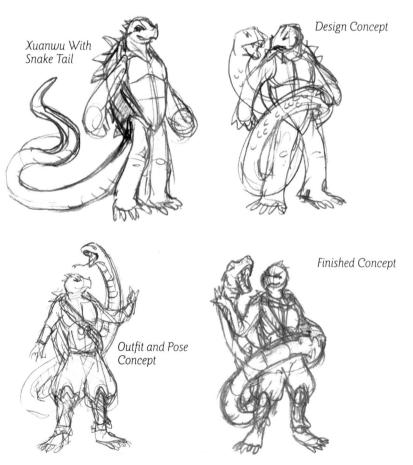

Xuanwu With Snake Tail

Design Concept

Outfit and Pose Concept

Finished Concept

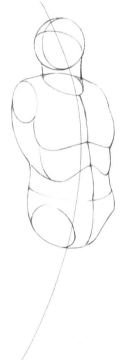

1 Brainstorm Character Design
Do some thumbnail sketches for your anthro Xuanwu's design and pose. Explore ways to combine the tortoise and snake figures. One approach is to draw him with a long snake's tail, but let's give our anthro a full snake companion. Think about how the tortoise and snake might interact: Do they cooperate, or does the snake throw deadly hissy fits?

2 Sketch the Body Position
Start with a line of action with a nice, subtle curve. Draw a sphere for the head. Use crosshairs to indicate an uptilt position. Draw a thick torso segmented like a turtle's plastron (lower shell) scutes.

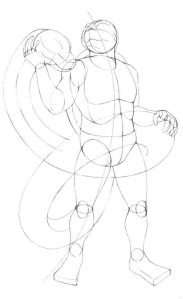

3 Build up the Shapes

Draw a stubby beak, cheeks and brow to fill out the shape of Xuanwu's turtle face. Sketch a turtle shell affixed to his back. Then draw his snake-tail, starting at the base of his spine, looping around his body and finally pulling forward to overlap his shoulder with its head. Leave enough room inside the snake's coils for his turtle torso to fit. Sketch Xuanwu's arms interacting with the serpent tail, cupping the snake's face in his right hand and resting his left hand on the coil. Finally, draw his legs in a sturdy, wide gait.

4 Sketch the Outfit With Feng Shui Flow

Dress Xuanwu in his warrior garb; billowy pants secured by a wide waistband, arm and leg armor and a sash. With a stationary pose like this, action is minimal, so look for ways to create flow through the placement of details. For example, draw a sash diagonally across the chest, and add a curving fold to the center of the pants to lead the eye from his right foot to his face (and back again through the body of the snake).

5 Detail the Figure

Fill in Xuanwu's turtle and snake facial features (eyes, mouths, nostrils). Give the snake a flicking tongue. Cover the snake with diamond-shaped scales, you just need enough to suggest texture. Add larger flat scales to the snake's belly. Detail the ridge of the turtle shell and add some horny scutes. Draw claws on his fingers and toes. Refine the details of the clothing, then erase your guidelines.

6 Finish With Color

As his name suggests, Xuanwu (which means "black warrior") is traditionally depicted in dark tones. I used black for his shell and claws, and dark green for the body. He needn't be completely devoid of color, however; try shades of plum, cherry blossom and jade on the outfit to add vibrancy. Then, build up your shadows and highlights. For the finishing blow, work in some texture to give the body a scaly, rough appearance.

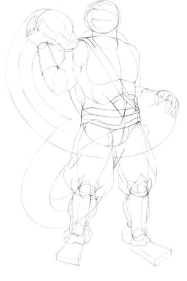

Turtle Shell

Made of bony plates, the shell shields its turtle or tortoise owner from the elements and from predators. The characteristics of the shell depend on the species and can range from soft and leathery to hard and spiny, flat to high-domed. Colors, number of scutes and pattern complexity also vary. Study photo references of your target turtle for inspiration on the details.

Turtles cannot slip out of their shells like they do in cartoons. The shell is an integral part of their skeletal anatomy, fused with the spine and ribs. However, for the sake of clarity in this demonstration, we've omitted the turtle resident to focus on the shell itself.

Turtle in a Half Shell
It helps to think of the shell as an egg cut in half.

1 Sketch the Basic Shape
Sketch the upper half of the turtle shell, called the carapace, as a half-egg shaped dome.

2 Add the Plastron Shape
Sketch an oval for the lower shell, known as the plastron, floating in front of the carapace. Leave enough space for your anthro turtle's arms, legs, head and tail. Sketch a middle section to connect the halves. Then divide the plastron with a line down the center.

3 Refine the Shape
Add an outer ridge to the carapace. Detail the front of the plastron with bony scutes sculpted into a chest-like shape. You can stylize the scutes to suggest human pectoral and abdominal muscles or stick with a more traditional turtle pattern.

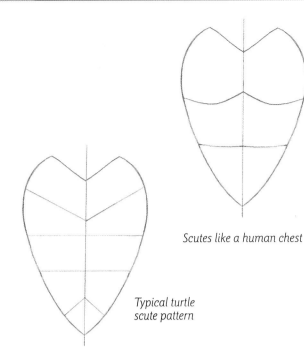

Scutes like a human chest

Typical turtle scute pattern

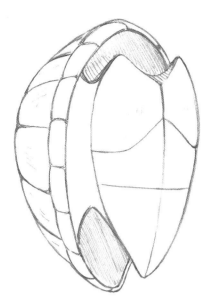

4 Detail the Shell

Erase any guidelines and refine your line work. Divide the carapace and ridge into scutes, following the curvature of the form. For texture, add some hatch lines. To give the shell a greater sense of depth, lightly shade the interior with your pencil. At this point, you can consider your turtle shell drawing complete if you're going for a simple, smooth design.

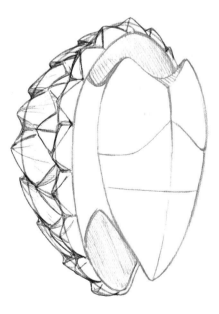

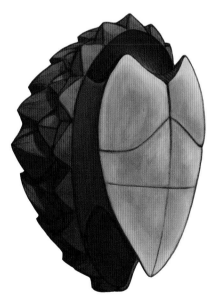

5 Add Spikes

Some turtles, like the alligator snapping turtle, have spiky raised scutes on their back. To create the look, extrude the scutes into a series of pyramids. Then erase the original scutes.

6 Finish With Color

Common turtle shell colors are muted brown, black or green tones. Apply some blotchy textures. Then, build up your shadows. Add highlights to give it a nice, glossy sheen.

Hybrid Furries

Like the chimera of Greek mythology (a creature made of goat, serpent and lion parts), a hybrid furry combines physical traits from two or more animal species. If you think about it, a furry is already a hybrid, so making a hybrid furry is simply taking it one step further by mixing in multiple animals. Extra animals add complexity, but the benefit is that you're more likely to create a unique new character. There's hundreds of wolf anthros, but how many zebra-striped pig-tigers are there?

The Stuff of Legends

You've already drawn a number of hybrid furries, like the griffin (lion-eagle), the kirin (deer-ox-carp) and the jackalope (jackrabbit-antelope). There are numerous other examples from mythology, such as the dream-devouring baku from Eastern folklore, a nightmarish blend of elephant, bear, goat, ox and rhinoceros; the winged horse Pegasus and the fish-horse hippocamp of Greek mythology. But your hybrid anthros need not be limited to the classics. The real fun comes from thinking up your own chimeric legends!

One of a Kind

Inspiration for your hybrid anthro can come from anywhere! In addition to combining two or more mammals, birds, insects, reptiles, amphibians or fish together with your human base, also consider non-specific features, like extra horns, wings or tails. Adding multiple, outrageous colors or infusing your creation with patterns, symbols or interesting motifs like flowers, fruits, seasons (winter, spring...) or elements (fire, ice...) can further contribute to their originality.

Inspired by Nature

When combining two animal species together, you might just stumble upon one that actually exists in nature! Take for example, the prizzly, a crossbreed of the polar bear and grizzly bear. Other examples of hybrid offspring include the mule from a donkey and horse; the liger from a lion and tiger and the coydog from a coyote and dog. Such hybrids typically only happen between closely related species and even then are rare, so don't expect to find a real-life equivalent for your butterfly-panda.

Bearflyon

Here's an example of a combination bear-butterfly-lion hybrid. The bear is the primary base, comprising her face and body. The lion comes through the tail and neck ruff and the butterfly through the wings.

Try It!

Time to get creative! Think of two or three of your favorite animals, and combine them to make a new furry. Before you start, consider which animal is the base and which to use for secondary features.

Blue Aura
Meet Bonnii's fantasy deer-feline hybrid, Aura, a cheery little creature whose blue fur spots, horns and claws glow in the dark or when she is happy. Illustrated by Jennifer Lynn Goodpaster Vallet (a.k.a. CookieHana).

TigerTaur
Example of a Felitaur, a species of taur consisting of the lower body of a big cat combined with an anthro cat torso. Illustrated by Denise "Doornob" Beaubien.

Taurs

A different kind of hybrid furry that combines the upper torso of a human or anthro animal, with the body of a nonanthropomorphic animal, taurs originate from the centaurs of Greek mythology (creatures with the upper torso of a man and the lower body of a horse). Most taurs are quadrupeds, but additional legs or none at all (snake-bodied creatures like the Naga), are not uncommon.

Part 1: Developing an Idea

By now, you should be comfortable drawing anthropomorphic characters in a variety of different poses. If you're ready to start thinking about the big picture, integrating backgrounds can enrich your artwork, and turn a static character design into a scene that tells the story.

There's a lot to think about in creating a scene, from character interaction to backgrounds and perspective. Don't worry! In this multi-part demonstration, we'll walk you through the entire process, step-by-step, from basic idea to polished colors.

The Five Ws

Who, what, where, when, why and how: the five Ws (and one H) of journalism apply to illustration. Your characters are the who, their actions are the what and why, setting is the where and when, and the way you compose this information into an illustration is the how. While all five are important, you don't need to approach them in a particular order. Inspiration for an illustration might stem from a character design, a theme, a story idea or even a location. Start from there and use the five Ws like a checklist to help you transform your idea into a fully rounded picture.

Who

Who are the characters in your scene? Think about their personality and backstory: What are they like? What is life like for them? What's important to them? Consider their appearance and do some exploratory sketches to feel out your characters. Keep it loose and don't worry about perfection; anatomy and pose aren't important at this stage.

Where

Where does your scene take place? Indoors or outdoors? Is everything new and pristine, well worn and decrepit? Also, consider props.

Gather reference photos and do some exploratory sketches to work out the details. You may also want to sketch a rough floor plan to help position characters and objects.

When

When does your scene happen: present day, the future, the past? Morning, afternoon, night? Season? When determines the look of a setting, the lighting, shadows, seasonal colors and even the types of clothing your characters are wearing (e.g., warm clothes in winter or modern clothes in a present-day setting).

What *and* Why

What the characters are doing in the scene and why they're doing it defines the characters' motivation for their actions. This can be as simple as a character lifting the lantern to illuminate a map, or as complex as a character scheming for world conquest. Think about how best to pose each character, making full use of body language and facial expressions to clearly communicate the intended action.

And How!

It's time to don the director's hat and consider the best angle, framing and positioning for your characters and the scene. Sketch your composition ideas in thumbnail form while keeping in mind your goals for the drawing. Keep sketching until you're satisfied—putting the work in now ensures that you'll end up with a picture you love.

Snow Leopard Away From Home
She left her snowy mountains to establish herself on the high seas. Somehow, through a series of misadventures, she became not just the captain of her own ship, but a pirate as well. These sketches explore the design and no-nonsense demeanor of our lead character.

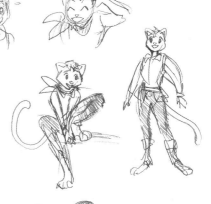

◀ **Swashbuckling Piggy**
Swashbuckling Piggy
Skilled in swordplay and full of pep, this one didn't fit the scene, so I replaced her with another character. Don't be afraid to abandon a sketch that isn't working. You don't have to use every character you create.

Hog with a Hidden Motive
This ill-tempered first mate does his fair share of work on the ship, but he's just waiting for the right time to snatch the treasure. Let some of his surliness show through in his expressions. I gave him a stout build, and left off the hair in his final design for a tough guy look.

Calico Cabin Boy ▶
He joined the crew after falling head over heels for the captain. Good-natured but timid, he's decidedly not pirate material. Accentuate his cuteness by rendering him with wide eyes, a lean build and a bandana.

Treasure Hunt ▶
These sketches of objects are for a scene within the captain's room on a pirate ship and include lantern designs, a cat skull emblem and banner, a treasure map, a compass, jewels and coins.

Thumbnail Compositions

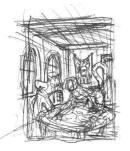
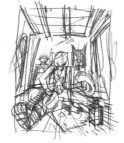
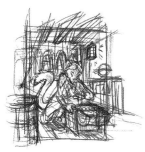

Close Study
This finished composition sketch shows the captain looking over her treasure map with the first mate while the helpful cabin boy casts a light on the scene. This is a night scene, so the characters must rely on the small lantern as their primary light source.

Part 2: Putting Things in Perspective

Using a technique called *linear perspective,* it's possible to represent our three-dimensional world accurately on a flat, two-dimensional piece of paper. Linear perspective is important for illustrating scenes, both for drawing the background and positioning characters within it. The technical aspects of perspective make it confusing and frustrating to grasp at first, but if you stick with it, you'll have a powerful tool for enhancing the illusion of depth in your drawings.

In this section, we'll go over the basics of linear perspective and then show you how to apply it to your illustration.

Elements of Linear Perspective

The three types of linear perspective you'll commonly encounter are one-, two- or three-point (based on the number of vanishing points required). All types consist of the following components:
- **Horizon line**: a horizontal line representing the eye level of the viewer
- **Perspective lines**: lines that converge at a point on the horizon
- **Vanishing points**: points on the horizon at which perspective lines converge

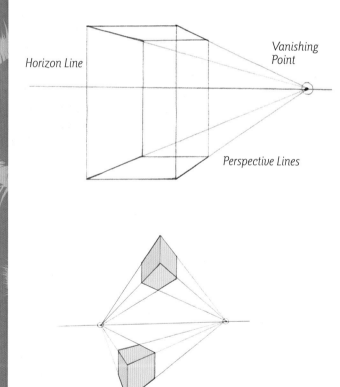

Horizon Line

Vanishing Point

Perspective Lines

One-Point Perspective
When drawing an object, like this cube, in an image where you can see its front face and one of its sides, use one-point perspective. Diminish the object's side face into the distance by drawing the converging lines to a single vanishing point on the horizon. If there were other objects in the image, you'd use the same vanishing point for them. For the cube's front face, draw the top and bottom lines parallel to the horizon and the vertical lines perpendicular.

Three-Point Perspective
In three-point perspective, all lines converge to a vanishing point. Three-point perspective is useful for giving your picture a dramatic feel by emphasizing height. Start with two vanishing points on the horizon, and then add a third point either above or below the horizon. Three-point perspective is also called bird's-eye view (when the third vanishing point is low), or worm's-eye view (when it's high).

Two-Point Perspective
Use two perspective points to realistically depict an object's depth when viewed from slightly askew angles. Draw the left side of an object receding to a point on the left and the right side to a point on the right.

1 Establish the Perspective

Study your thumbnail composition to determine if it calls for one, two, or three-point perspective. One-point perspective works well for tight indoor scenes like this ship cabin interior. Sometimes elements in your sketch will offer clues. Here, the wood floor and ceiling lines point to a single vanishing point on a horizon line in the center of the drawing.

2 Block in the Background

On a fresh sheet of paper, draw the horizon line and clearly mark your vanishing point. (I like to circle it so it doesn't get lost.) Block in the back wall of the room using horizontal and vertical lines. To suggest a ship interior, draw the vertical lines of the side wall with a gentle slant. Keep the angle consistent for the window frames and wood panels along that wall. Pull all converging lines to the vanishing point. For the floorboards, start from the back wall and use a ruler to mark the equal distance between boards. Then align your ruler with the vanishing point and extrude the lines.

3 Continue to Build up the Background

Draw the ceiling boards the same way you did the floorboards. Then, sketch an X on each window frame to find the center, and draw a perspective line through it. Using the outer frame as the guide for consistency, sculpt the top of each window into a dome shape. Now let's furnish the room with a few objects. Sketch some boxes of varying sizes and draw the converging lines to the vanishing point. Try stacking a box on top of another box. To create the start of a barrel shape, repeat the X trick and draw a circular base.

Part 3: Drawing

In this section, you'll develop your rough perspective lines into a detailed background, then build up your characters and foreground elements to create a fully realized scene.

1 Detail the Background

Draw the window frame with equally spaced glass panes receding into the wall. Elaborate on the wood paneling and add a hanging kitty-pirate flag to decorate the bare walls. Add detail to your boxes to transform them into pirate-themed goods, like barrels and chests. With the basic structure in place, set aside the ruler and freehand the lines of your background to give it an organic look. Allow your pencil a little wobble to add imperfections and warping on the boards and wood grain.

2 Block in the Characters

Sketching lightly, block in the foreground table and characters in their approximate positions. If you're concerned about messing up your background art, sketch them on an overlaid sheet of tracing paper. At this stage, keep your lines rough and loose. Focus on form and pose, working up from basic shapes. Keep in mind that the vanishing point you used on the background also applies to characters and the objects they are holding.

3 Refine the Characters

Before tightening your drawing, check your rough sketch by putting it up to a mirror. Looking at your drawing in reverse can help you spot mistakes. Make any necessary adjustments to improve visual flow or other problems (I increased the pig's height and bulk, and redrew the snow leopard's body and left arm). Then refine the character's figures and expressions.

4 Finish Characters and Foreground Details

Working through one character at a time, add details using your design sketches for inspiration. Give the cabin boy a dagger and lamp. Draw the snow leopard's vest, bow and wavy hair. Clean up the lines on the pig. Add fur texture to the felines. Don't forget to draw the pirate map and other objects on the table. Tighten your lines and erase any guidelines or stray marks.

5 Complete the Drawing

Unify your characters with the background (if you drew them separately). Then do any necessary tweaking to get the level of detail consistent between the background and character art. Erase your vanishing point and any perspective lines. Finally, crop your picture if necessary to fit your original planned composition and framing. It's ready for color!

Part 4: Coloring

In this section, you'll color and finish your illustration, starting with choosing mood colors, determining the light source, building up shadows and highlights and ending with the finishing touches!

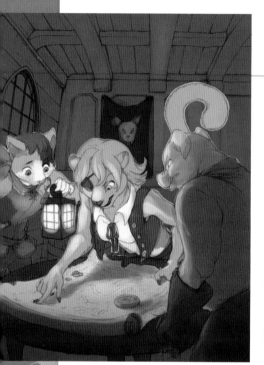
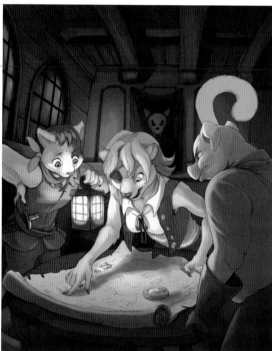

1 Block in Colors

Decide on a color scheme to set the mood and time. Because this nighttime scene involves pirates discussing hidden treasure, I chose cool blues for the background and warm reds and yellows in the areas illuminated by the lantern.

For the characters, I used species-specific colors: silvery gray for the snow leopard, a ruddy brown for the pig and orange, white and black for the calico cat. With a large illustration like this, you may wish to experiment with a couple of different color schemes on a duplicate of your drawing. Once you're satisfied, fill the areas of your picture with your chosen base color tones.

2 Build up Shadows and Highlights

Determine the light source. With only night sky and deep ocean beyond the windows, the sole light in the scene is the lantern.

Deepen your shadows in the areas devoid of light, such as under the table, the back wall, behind wooden beams and the characters' backs. Work some reds into the background to add warmth and help unify it with the foreground. Use a yellow hue matching the glow of the lamp to brighten areas most exposed to the light.

3 Refine and Blend Colors

Working from background to foreground, refine your colors one section at a time. Increase shadows and highlights in the darkest and brightest areas. Add texture details, such as grain on the wood and frosted gloss to the glass panes. Paint over any colors spilling outside of lines.

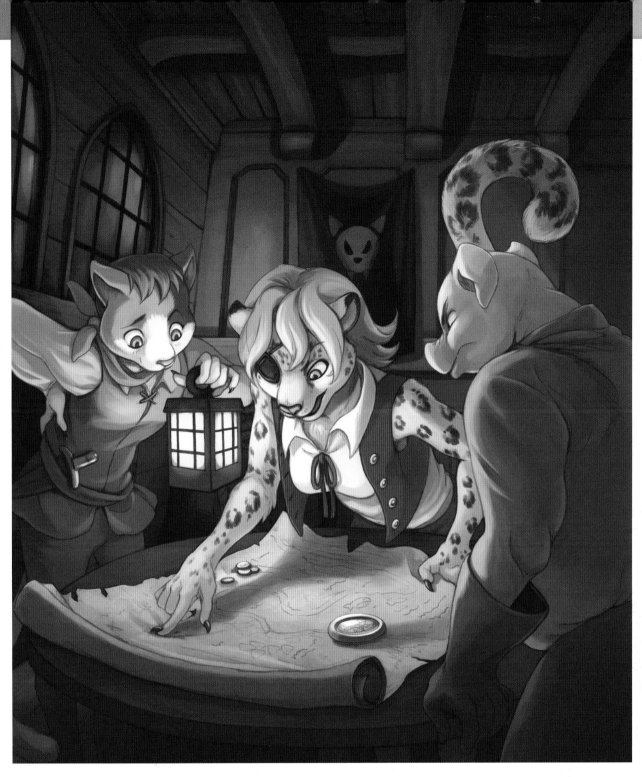

4 Add Finishing Touches

Make final refinements to the characters and foreground elements. Spend some extra time polishing the character's faces, a focal point of the illustration. Puff up the calico's sleeves with some yellow highlights. Add some reds to the back of the pig's shirt (indicating reflected light). Give the snow leopard her signature rosettes, taking care to shape the fur pattern to her body contours. Apply more highlights to the metallic objects, like the dagger handle, coins and compass, to give them a lustrous shine.

Thar Be Treasure
by Lindsay Cibos

Index

About the Authors

Lindsay Cibos and Jared Hodges are an artistic duo specializing in illustrations and sequential art. They are the creators of the graphic novel trilogy, *Peach Fuzz*. Lindsay and Jared have also authored several art tutorial books, including IMPACT's *Draw Furries: How to Create Anthropomorphic and Fantasy Animals*, recipient of the 2009 Ursa Major Award for Best Other Literary Work. They currently reside in sunny central Florida. Visit them on the web at www.jaredandlindsay.com! You can read their newest comic series, *The Last of the Polar Bears*, at www.lastpolarbears.com.

Acknowledgments

We would like to express our gratitude to:

- Our families for their love and support.
- Everyone at F+W Media, in particular, Pamela Wissman; our editor Vanessa Wieland, for her insights and encouragement and Amanda Kleiman for beautifully arranging our art and words into book form.
- Illustrators Kelly Hamilton, Kacey Miyagami, Kristen Plescow and Nimrais for their outstanding work on the chapter openers.
- Artists Denise Beaubien and Cookiehana, and photographer Heather Quevedo, for their permission to include their lovely work in this book.
- Sarah Elkins, for being a tremendous help by prepping art files during in the final stretch.
- The furry community for their support and enthusiasm for the project.
- Readers of *Draw Furries* for their invaluable feedback, which ultimately led to the creation of this follow-up book.
- And a very special thanks to you!

Other fine IMPACT Books are available from your favorite bookstore, art supply store or online supplier. Visit our website at fwmedia.com.

16 15 14 13 12 5 4 3 2 1

DISTRIBUTED IN CANADA BY FRASER DIRECT
100 Armstrong Avenue
Georgetown, ON, Canada L7G 5S4
Tel: (905) 877-4411

DISTRIBUTED IN THE U.K. AND EUROPE
BY F&W MEDIA INTERNATIONAL, LTD
Brunel House, Forde Close, Newton Abbot, TQ12 4PU, UK
Tel: (+44) 1626 323200, Fax: (+44) 1626 323319
Email: enquiries@fwmedia.com

DISTRIBUTED IN AUSTRALIA BY CAPRICORN LINK
P.O. Box 704, S. Windsor NSW, 2756 Australia
Tel: (02) 4577-3555

Edited by Vanessa Wieland
Designed by Amanda Kleiman
Production coordinated by Mark Griffin

A Final Word of Advice

It is our sincere hope that this book helps to inspire you and provide you with a foundation to create your own anthropomorphic characters. Don't be discouraged if your first attempts don't come out the way you pictured them in your head. Proficiency with the pencil doesn't happen overnight. However, we promise that if you keep drawing, your efforts will be rewarded. Practice makes perfect, so start a sketch book and set aside time every day to draw some furries! Good luck!

Ideas. Instruction. Inspiration.

Download FREE bonus materials at impact-books.com/more-furries.

Check out these **IMPACT** titles at impact-books.com!

These and other fine **IMPACT** products are available at your local art & craft retailer, bookstore or online supplier. Visit our website at impact-books.com.

Follow **IMPACT** for the latest news, free wallpapers, free demos and chances to win FREE BOOKS!

IMPACT-BOOKS.COM

- ▶ Connect with your favorite artists
- ▶ Get the latest in comic, fantasy and sci-fi art instruction, tips and techniques
- ▶ Be the first to get special deals on the products you need to improve your art